IMAGES
of America

CARDIFF-BY-THE-SEA

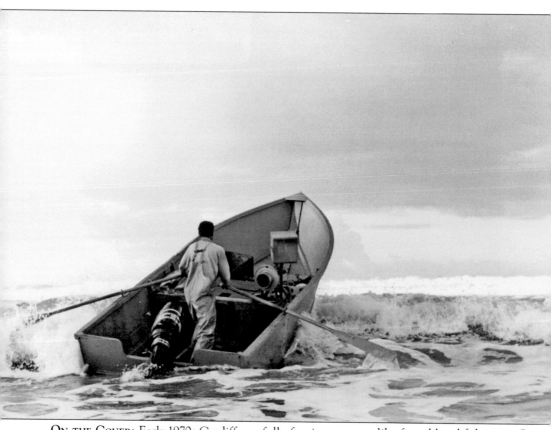

ON THE COVER: Early-1970s Cardiff was full of unique scenes, like famed local fisherman Stan Lewis plowing through the surf at Cardiff Reef en route to a long day of fishing. Lewis staked his legacy as a doryman, navigating his wave-worthy vessel out to retrieve coveted Pacific spiny lobsters and various fish off the coast. Taken in 1971, this photograph captures the essence of Cardiff's water-based culture. Whether living from the bounty of the ocean, surfing its waves, maintaining a view of the sun setting at its horizon, or basking in the reflection, Cardiff's past, present, and future are most clearly seen through the lens of the Pacific. (Copyright © 1971 by Robert M. Wald.)

IMAGES

of America

CARDIFF-BY-THE-SEA

Wehtahnah Tucker and Gus Bujkovsky

ARCADIA
PUBLISHING

Copyright © 2009 by Wehtahnah Tucker and Gus Bujkovsky
ISBN 978-0-7385-6951-2

Published by Arcadia Publishing
Charleston, South Carolina

Printed in the United States of America

Library of Congress Control Number: 2008935201

For all general information contact Arcadia Publishing at:
Telephone 843-853-2070
Fax 843-853-0044
E-mail sales@arcadiapublishing.com
For customer service and orders:
Toll-Free 1-888-313-2665

Visit us on the Internet at www.arcadiapublishing.com

*To the children of Cardiff past, present, and future. May you always
feel your roots firmly planted in the rich history of your community.*

And to Tommy Lewis, a true waterman. You will be missed by many.

CONTENTS

ACKNOWLEDGMENTS

Crafting a historical book revealed through photographs would be an arduous process at best if it were not for the illuminating tales told without hesitation. There is a wellspring of committed individuals and families who have generously given not only their personal photographs to proliferate Cardiff's history, but also their time.

Foremost, I would like to thank Irene Kratzer, whose early support of this project was imperative. Her abilities as a liaison rival those of anyone at the highest levels of international protocol. Members of the Friends of the Cardiff-by-the-Sea Library and Cardiff 101 Chamber of Commerce helped to frame the broad strokes and give depth to seemingly trivial historical facts. Special thanks to Rosann Drielsma and Lloyd O'Connell for setting the proverbial ball in motion with the Encinitas Historical Society and others whose input proved invaluable.

One of the most surprising pleasures of researching the book was developing relationships with the eclectic characters of Cardiff. More than once I was invited into people's homes for a conversation, a cup of tea or coffee, even a home-cooked meal. I hope that I can reciprocate the kindness so freely offered to me by the community.

Without the following people, this book would not have been possible: Councilwoman Teresa Barth, Tommy Lewis, *Ocean Magazine* publisher Robert M. Wald, Linda Benson, Bobby and Dick Lux, Jay and Wanda Williams, Chris and Jim Machado, Rosemary Smith KimBal, Dorothea Smith, Ken Harrison, Jane Schmauss, Don Hansen, Councilman Dan Dalager, Bob Bonde, Wendy Haskett, Billy Stern, *Coast News* publisher Jim Kydd, Doug White, Diana Brummett, Shirley Schroeder, Rick Mildner, and Scooter "Cappy" Leonard.

Without Gus Bujkovsky's technical expertise and genuine appreciation for the preservation of local history, these images and stories would still be buried deep in my computer.

Finally, thanks to my family, who has been a tremendous resource of strength and courage. To my Grandma Pat, who taught me that history does not exist in a vacuum and neither does the present, a deeply felt thank-you. To the greatest love of my life, Shawlin, thank you for your patience and tolerance of Mom's "book work." You inspire me every day to look beyond the confines of what is merely necessary into a world full of possibilities.

INTRODUCTION

The history of Cardiff-by-the-Sea is steeped in the pull of possibilities, which ground the soul of the city. Its future lies there as well. The process of discovering this Pacific hamlet occurs differently for each resident, each new arrival, each visitor passing through.

For Hector MacKinnon and his family arriving from Cleveland, Ohio, in 1875 to the northern mouth of the San Elijo Lagoon, the unchartered territory held the dawning of a new era. Along with his wife, Sarah, MacKinnon set out to prove wrong the naysayers who doubted farming could be successful so near the coast. Their 600-acre homestead yielded barley and corn. The couple raised livestock, using their cows' milk and chickens' eggs along with jams from the orchard produce to sustain the family during lean years.

The MacKinnons opened a school in their barn in 1881 and brought the first teacher, Mrs. Wood, to begin a six-month teaching contract. During the great snowstorm of 1882, students huddled around the wood-burning stove in the kitchen of the main house to continue their lessons in relative comfort.

In 1910, a Boston painter by the name of Frank Cullen arrived in the area. His plan to develop the swampy expanse into what he hoped would become a "coastal playground" soon began to take shape. Purchasing a portion of MacKinnon's land proved to be the easiest part of the plan. Cullen plotted the town site with residential and commercial elements firmly in place on the map. He began selling inside lots for $30 and corner lots for $45. The wide expanse of the rolling hills cascading upwards from the Pacific gave each buyer a view that perpetuated Cullen's vision of paradise.

Cullen's wife, Esther, encouraged her husband to name the new town after her native Cardiff, Wales. The British street names, such as Birmingham and Manchester, remain in place despite the heavy Spanish influence in the area.

Cardiff's only industry was a kelp works plant founded in 1912 by Clarence Cole. The Olivenhain pioneer processed the seaweed for use in food and industrial applications such as potash, an ingredient in gunpowder. After World War I, the demand for potash declined dramatically and the plant was dismantled. Lumber from the building was used to support the newly created Cardiff train depot in the 1920s, which remains the anchor of the town's business district at the northeast corner of Chesterfield Drive and George's Inn. The foundation can still be seen during low tide along the muddy northernmost banks of the San Elijo Lagoon.

A proper educational infrastructure, the Cullen School, replaced the one-room school in MacKinnon's barn in 1914 on land donated by Cullen. Cardiff Elementary School District supports two outstanding schools today.

Music arrived with an understated flair in 1916, as Victor Kremer, a German-born composer and musician, moved to the area. Envisioning an artists' colony, he developed the Composer District, an area with street names such as Verdi and Hyden. The addition of "by-the-Sea" is attributed to Kremer as he drew inspiration from the 1914 hit song "By the Beautiful Sea."

His wife, Eugenie, also had a rare passion fruit vine growing in the backyard, which they developed into a brief but thriving business. Creating the sought-after drink Passionola, Cullen hawked his concoction along the quickly developing coastal waterfront. However, in 1937, an unlikely freeze turned the passion fruit vines and avocado orchards into ice. The golden crops never recovered from the bitter frost.

A rush of development occurred with the opening of the city's first library in 1914. In addition to a post office, the 1920s brought a train station, dramatically increasing the ease with which people and products could travel. The formation of the San Dieguito Irrigation District finally made water available on a scale that allowed commerce to flourish.

Following slowed development during the Great Depression and World War II, surfing took hold in Cardiff as locals began riding the many breaks between Seaside and Swami's. The surf industry, as it grew in the 1960s and 1970s, migrated to the town as well. World-class surfboard shaper Don Hansen set up shop in a small building south of the lagoon. His presence, along with pro surfers Linda Benson and later Rob Machado, helped solidify Cardiff's reputation as a surf town.

During a protracted, antagonistic battle with San Diego County to incorporate the area known as San Dieguito, Cardiff debated whether to join four other neighboring communities in forming the modern-day city of Encinitas. Although residents voted to become a part of the newly formed entity, they were adamant that Cardiff maintain its own zip code, post office, and school district. Cardiff retained autonomy in the spirit of preservation.

One

THE BEGINNING

OF A DREAM

Hector MacKinnon traveled west in 1875 from Cleveland, Ohio, with his wife, Sarah, and their children. Their journey took them to San Francisco by train, San Diego by steamer, and finally to modern-day Cardiff by horse and buggy. The family settled on 600 acres three-fourths of a mile from the mouth of the San Elijo Lagoon, intent to farm the area despite the folly of growing anything so close to the coast. The nearest neighbor was more than 2 miles away.

While MacKinnon was marginally successful, the ranch was not enough to sustain his family. Sarah looked after the goats, chickens, corn fields, barley, and orchard while Hector traveled to San Diego for more consistent work as a machinist. Remarkable for her industrious nature, Sarah sold eggs, butter, and milk from the family's livestock along with her delectable jams.

A room in the MacKinnons' barn served as the region's first school. In 1882, as snow fell from the clouds to the ocean, the students and young teacher were moved into the family's kitchen to huddle around the wood-burning stove during lessons.

MacKinnon's early labors to establish the first ranch is commemorated by MacKinnon Drive in the heart of Cardiff.

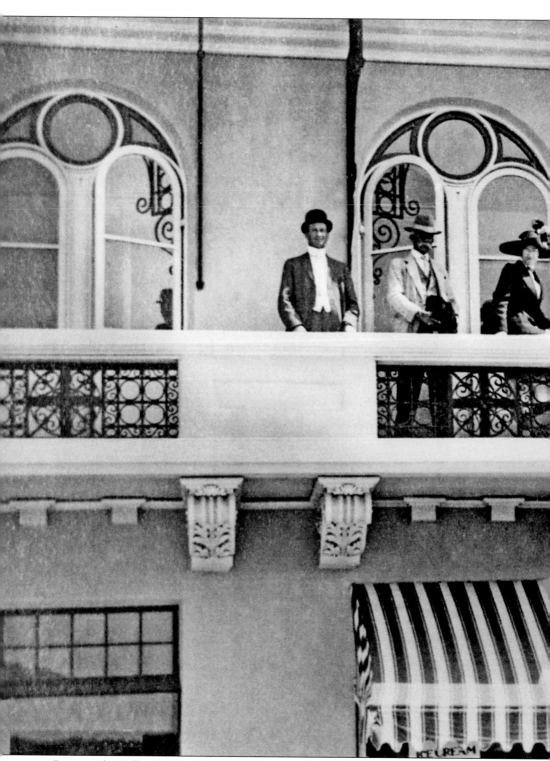

Guests at the Cullen Building Hotel, also known as the Cardiff Mercantile Building, dressed in their fine period apparel. Captured in this early-1920s photograph, it is one of the few remaining buildings

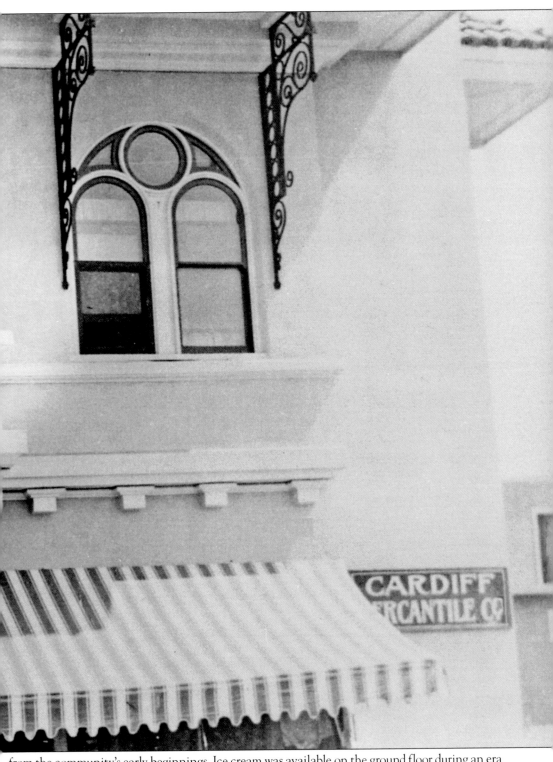

from the community's early beginnings. Ice cream was available on the ground floor during an era when water was hard to come by, much less ice. (Courtesy of the Encinitas Historical Society.)

This 1914 postcard depicts the early view from Swami's Point looking south along the high bluffs. (Courtesy of Ken Harrison.)

San Elijo Lagoon separated Cardiff from the Native American population thought to have lived on the southern edge of the slough. This 1950s photograph shows the area's propensity for flooding before proper drainage measures were taken by county and state authorities. (Courtesy of Doug White.)

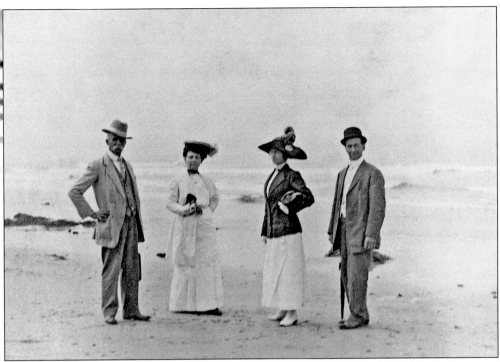

Visitors to the Cullen Building Hotel made their way to the beach, perhaps after a closer inspection of the possible living accommodations in the area. (Courtesy of the Encinitas Historical Society.)

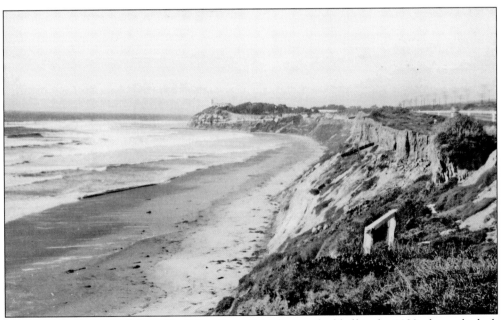

This scene looking north from Cardiff to Swami's high atop the bluff in the 1930s shows the lack of safety features along the section of Coast Highway 101. The small, white guardrail was all that separated drivers on the main thoroughfare from the edge of the bluff and a long tumble to the beach far below. (Courtesy of Ken Harrison.)

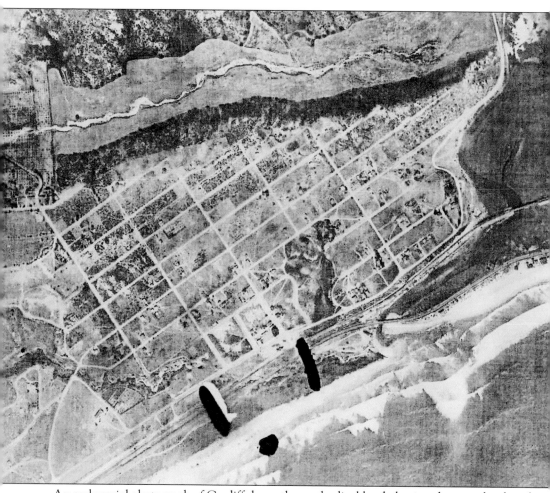

An early aerial photograph of Cardiff shows the methodical land plotting that was developed in the earliest stages of the town's development. (Courtesy of Billy Stern.)

Two

FROM PAINTER
TO LAND DEVELOPER

In 1910, J. Frank Cullen arrived from Boston. A painter by trade, the visionary saw a potential coastal playground in Cardiff and proceeded to purchase MacKinnon's land. The town was soon plotted, and Cullen began selling lots for $30 to $45. As an infrastructure developed, Cullen's wife, Esther, encouraged her husband to name the town after her native Cardiff, Wales.

Obtaining a consistent supply of water for the new town proved to be Cullen's biggest obstacle. Initially, a 2-inch main pipe carried water 3 miles from Cottonwood Creek to a storage tank on the hill overlooking Cardiff. The pump was operated by a gasoline engine that was not as reliable as was necessary for a growing town. Cullen was joined by other residents and business owners, many of them flower growers, in forming a water district that would bring a more consistent source of water to the town. Finally, in 1922, the San Dieguito Irrigation District was formed. The water storage tank was converted into a house and remains at the top of the town today.

Victor Kremer, a German-born music publisher turned developer, found his way to Cardiff and laid claim to the Composer District, north of Birmingham Drive. With street names like Mozart and Verdi, he envisioned an artists' colony. While his fellow musicians scoffed at the idea of living in a remote outpost, Kremer was not deterred. He set his sights on creating a drink from a wild passion fruit vine growing in his backyard called "Passionola." As fate would have it, a bitter frost put an end to his dreams of creating a new industry in Cardiff. His most lasting legacy is the addition of "by-the-Sea" to Cardiff, taken from the popular 1914 song "By the Beautiful Sea."

By the 1920s, a train depot, library, school, restaurants, a hotel, mercantile exchange, and a post office had brought new residents and commerce to Cardiff. Cullen's vision was slowly coming together.

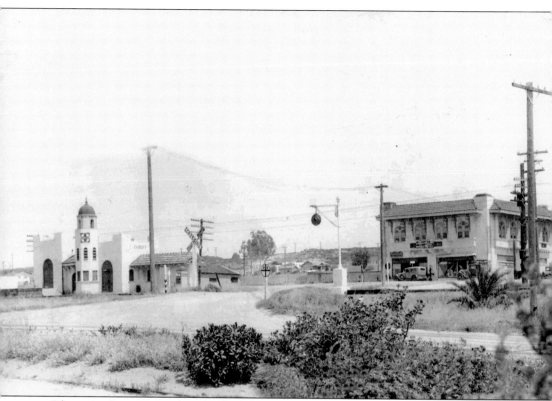

The train depot pictured in the far left corner helped put Cardiff on the map as goods moved more easily between Los Angeles to the north and San Diego to the south. (Courtesy of Rosann Drielsma.)

This 1920s photograph shows the Williams family enjoying the bountiful playground provided by the ocean. (Courtesy of Jay Williams.)

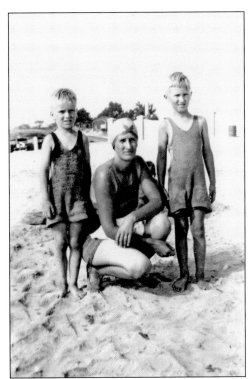

Bill "Red" McChesney surveys his gladiolus farm in 1935. The vast expanse of flowers covered the area where the Cardiff Town Center is now located. Notice the Cardiff Hotel in the top right of the photograph. (Courtesy of Rosann Drielsma.)

Albert Miller, a gladiolus farmer, contemplates the long haul to Los Angeles to sell the long-stemmed flowers that provided a living for many families in the Cardiff area. (Courtesy of the Smith family.)

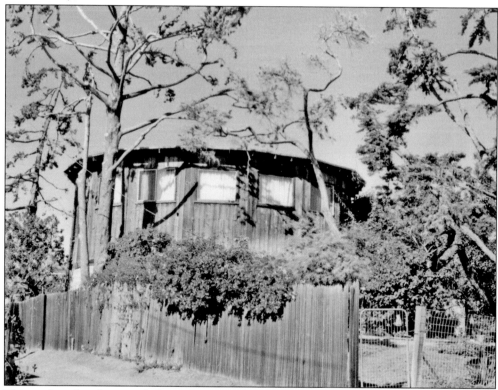

This modern-day photograph shows the town's first water storage tank. Although it was converted to a home and remains at the top of the town today, it served for many years as the holding place for water pumped from a 2-inch main pipe that carried water 3 miles from Cottonwood Creek. The pump was operated by a gasoline engine that was not as reliable as the growing town required. Finally, in 1922, the San Dieguito Irrigation District was formed. (Courtesy of Doug White.)

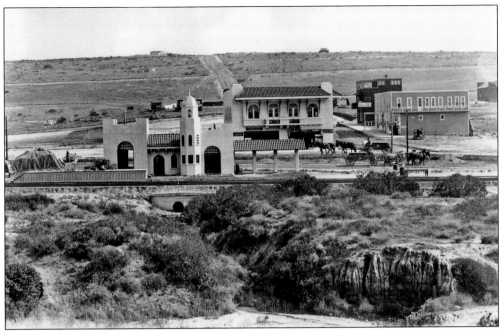

This 1911 photograph shows a developing landscape in Cardiff along the railroad tracks. Horse-and-buggy transportation, as seen in the lower right corner, was the most widely used method of transporting goods over short distances. Notice the two dirt paths that served as roads for early residents and visitors. (Courtesy of Rick Mildner.)

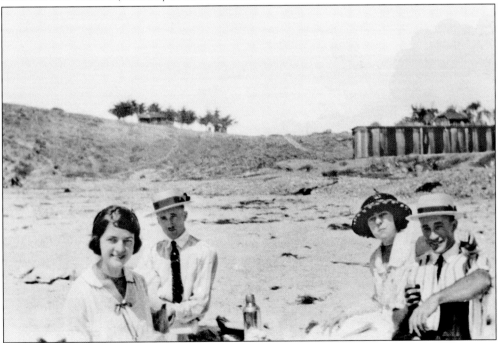

In the late 1920s, beachgoers were able to enjoy an expanse of coastline for recreational purposes. These unidentified Cardiff visitors took in the sun and fun during a casual picnic. (Courtesy of the Encinitas Historical Society.)

A gladiolus farm consisting of 20 acres located at Crest Drive is owned by Dorthea Smith. The 18-year-old bought the land with her inheritance for $250 in 1935. The industrious young woman became the matriarch of a family that has seen changes throughout the city's history and has contributed to its development. (Courtesy of the Smith family.)

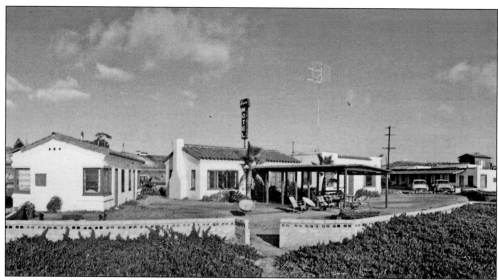

This photograph of the Evans Motel taken in the mid-1950s shows an area of the beach considered private. In the 1960s, all of the state's beaches were opened to the public (up to the median high-tide line). The motel was considered a modern marvel to travelers along Highway 101. (Courtesy of Ken Harrison.)

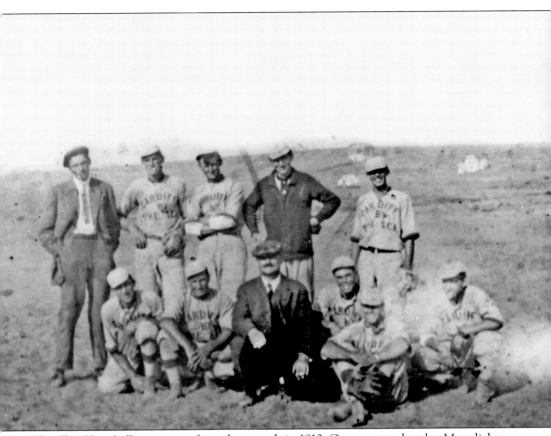

Cardiff's official baseball team poses for a photograph in 1912. Games were played at Moonlight Beach against the Encinitas team with hoards of spectators crowded to catch the action. (Courtesy of the Encinitas Historical Society.)

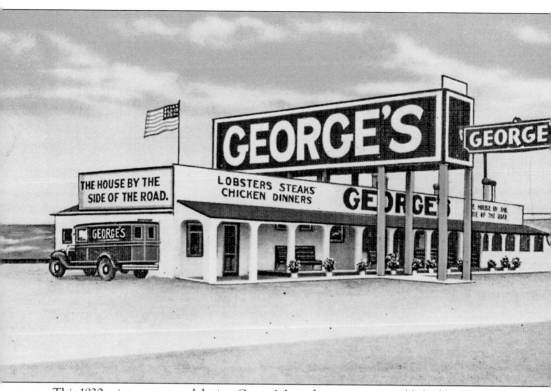

This 1930s vintage postcard depicts George's Inn, the restaurant established by George Beech in 1916. This major piece of what J. Frank Cullen envisioned as Cardiff's master plan was the only eating establishment between San Diego and Los Angeles on Highway 101. Beech would divert highway traffic to the restaurant during major holidays. The modern-day Chart House had all but one wall replaced when it remodeled the building in the 1970s. (Courtesy of Ken Harrison.)

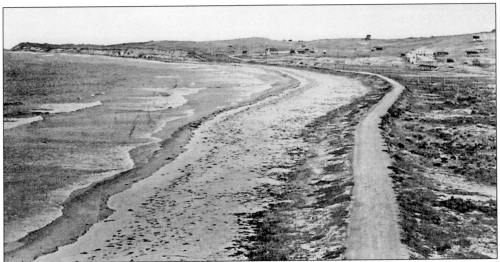

This postcard issued for the 1915 Panama California Exposition of the original Coast Highway 101 shows a still unnamed ungraded dirt road. The main thoroughfare soon became Highway 1. The largest building in the image is the Cardiff Kelp Works, located on the edge of the San Elijo Lagoon. Used to make potash, processed kelp was highly sought after during World War I. The building was one of the first structures erected after J. Frank Cullen subdivided the area. Built in 1911, the processing plant was the center of a thriving industry that quickly disappeared after the war's end. The building was dismantled by a local family, and pieces of machinery were carried by a horse-drawn wagon to the train depot. A few of the building's foundation posts are still visible during low tides at the northern end of the lagoon. (Courtesy of Ken Harrison.)

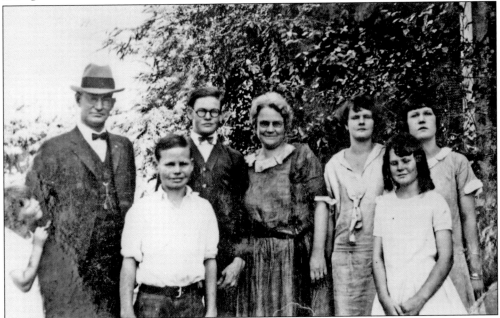

The McChesney family is pictured in the backyard of their house on Manchester in 1924. Patriarch Louis Preston (far left) was an inventor who owned McChesney Specialty Works. He was a plumber by trade who found time to invent a chicken drinker. The couple raised six children in the former Wells Fargo Stagecoach stop. (Courtesy of Rosann Drielsma.)

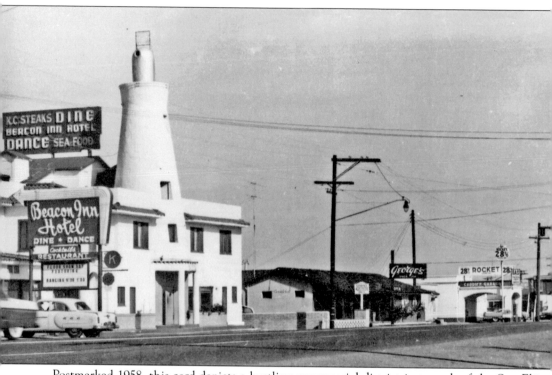

Postmarked 1958, this card depicts a bustling commercial district just north of the San Elijo Lagoon along the west side of Coast Highway 101. In addition to the Beacon Inn, which offered visitors not only accommodations but also the promise of local seafood and dancing, the strip housed George's Restaurant and the Rocket gas station, where one could fill up for 28¢ a gallon. (Courtesy of Ken Harrison.)

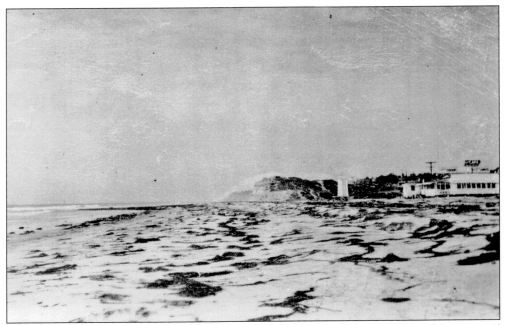

This 1950s photograph shows the wide expanse of beach in front of the high cliffs that comprised Cardiff's long stretch of coastline. The Breakers Café, long since abandoned and torn down, can be seen in the far right of the picture. (Courtesy of Doug White.)

Minehaha's Lodge, as the house at 2019 Manchester Avenue was affectionately called, was purchased by Louis Preston and Annie Bea McChesney in 1924. Prior to becoming a family home, it was a Wells Fargo Stagecoach stop. The home stayed in the McChesney family for 88 years until it was sold in 2008. (Courtesy of Rosann Drielsma.)

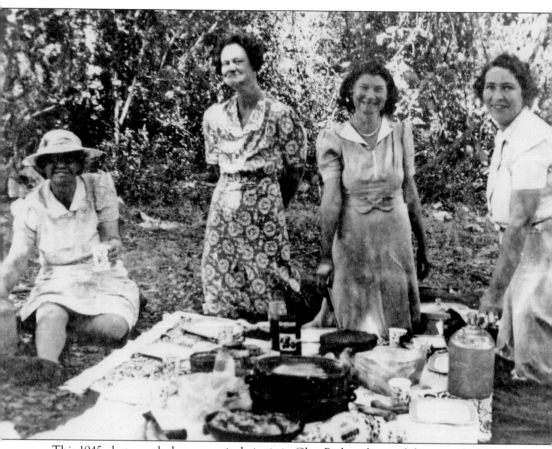

This 1945 photograph shows a typical picnic in Glen Park replete with homemade delicacies and women in fine dress. Pictured from left to right are Annie Bea McChesney, Lois Freeman, Audrey McChesney, and Helene McChesney. (Courtesy of Rosann Drielsma.)

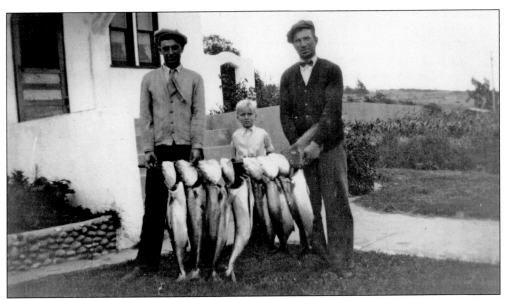

A young Jay Williams, pictured in the middle of his father, Day Williams (right) and family friend Jack Hawkins, marveled at the size and quantity of the fish brought in from the ocean just below his home along Montgomery Avenue in this 1920s photograph. (Courtesy of Jay Williams.)

Grace McChesney Pearson is shown in front of the Manchester family home in the 1920s. The stones covering the house were used to construct a beautiful fireplace indoors where the family would gather on chilly winter nights. (Courtesy of Rosann Drielsma.)

This 1917 photograph shows "Red" McChesney (far left) with two of his siblings in the early 20th century. (Courtesy of Rosann Drielsma.)

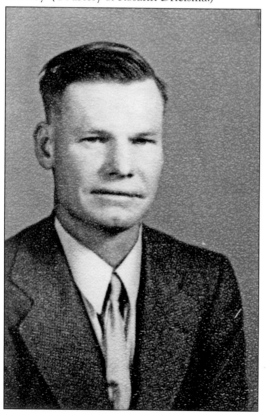

"Red" McChesney was one of six children raised in Minehaha's Lodge. His father, Louis Preston, was one of the founding members of the local Rotary Club and sat on the first board of trustees for the newly formed San Dieguito High School District beginning in 1937. (Courtesy of Rosann Drielsma.)

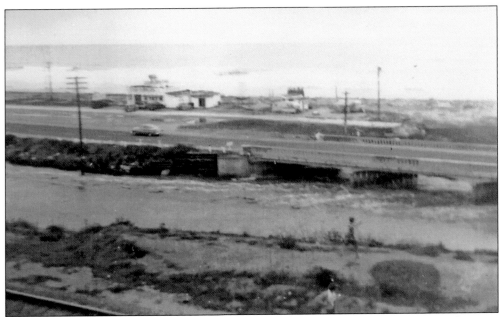

This 1950s photograph shows the southern edges of Cardiff along the San Elijo Lagoon as the water makes its way under Coast Highway 101 to meet the Pacific Ocean. (Courtesy of Doug White.)

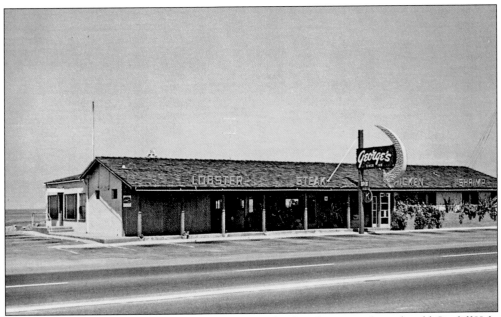

George Beech began building his inn in 1916 using lumber that came from the old Cardiff Kelp Works. The reputation of George's menu was attributed in large part to his vegetables, homegrown in his hillside garden along with prize-winning roses. Historical documentation states that sometime in 1920, the train stopped at the nearby station and George was ushered aboard, where he had a private visit with Pres. Woodrow Wilson. (Courtesy of Ken Harrison.)

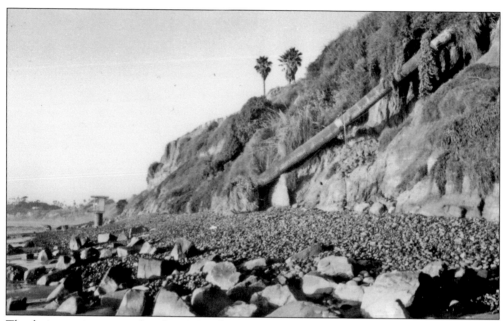

The drainage pipe pictured in this 1960s photograph gives this particular Cardiff beach its name: "Pipes." A popular café just across San Elijo with the same name serves up breakfast and lunch, popular with locals and visitors alike. (Courtesy of Doug White.)

This 1945 photograph taken at Glen Park shows, from left to right, Vernon McChesney, Rosann McChesney-Drielsma, Rosann's father, "Red," Grace McChesney, and Ted Meisner. The barbeque pit allowed the McChesney clan and other families to share a sense of community at the local gathering spot. (Courtesy of Rosann Drielsma.)

The McChesney family is pictured at the Manchester house in 1932. Louis Preston McChesney (top left), a local mover and shaker, was an early member of the San Dieguito Irrigation District, which brought a consistent source of water to Cardiff. (Courtesy of Rosann Drielsma.)

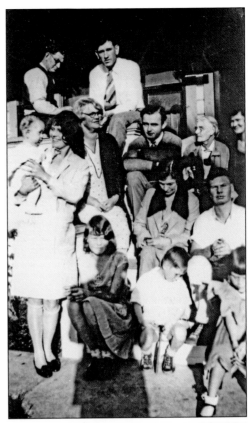

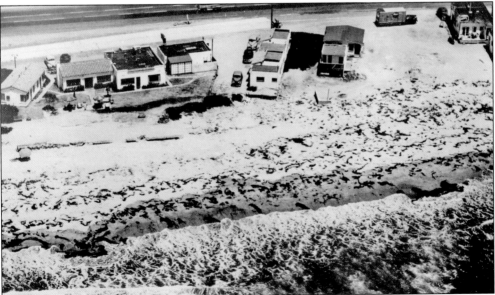

The Evans Motel, as seen from this undated aerial view, was a beachgoer's dream in the early years of the town's development. It was located west of the modern-day Restaurant Row along Coast Highway 101, and the only thing visitors had to worry about was the high tide. (Courtesy of Ken Harrison.)

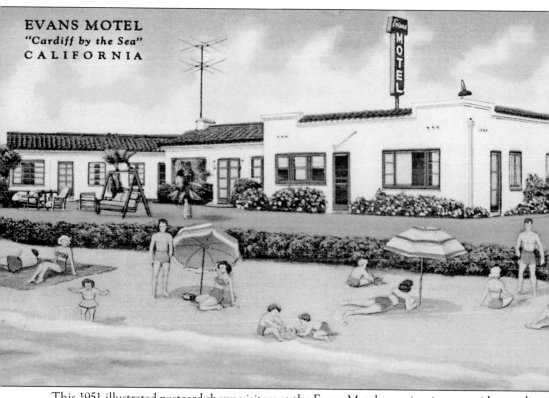

EVANS MOTEL
"Cardiff by the Sea"
C A L I F O R N I A

This 1951 illustrated postcard shows visitors at the Evans Motel experiencing a seaside paradise. This card was used to solicit business from the inland communities. The caption on back promises that tourists need only go "From Your Door to the Shore" to live the good life. (Courtesy of Ken Harrison.)

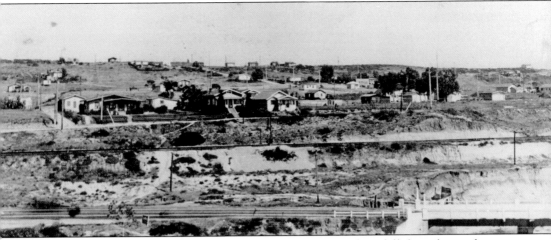

This undated photograph shows the early residential development of Cardiff along the northern edge of the San Elijo Lagoon. Despite persistent flooding, the lagoon area was a desirable location to build the unique bungalows that dotted the landscape east of the railroad tracks. (Courtesy of Rick Mildner.)

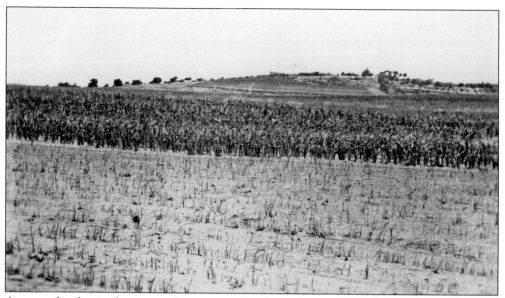

As many families in the surrounding area made a living from growing flowers, Dorthea Smith's 20 acres of gladioluses fit into the prevailing landscape. Kelp, which was plentiful in the ocean during this time, was used in the commercial flower operation for its various nutrients. (Courtesy of the Smith family.)

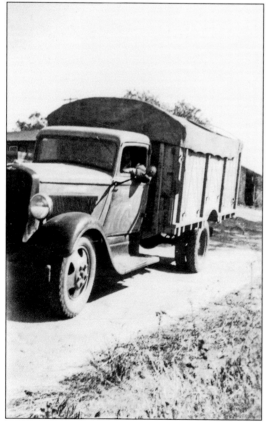

This early-1930s photograph shows one of the trucks that took gladioluses to the Los Angeles market. Departing during the pre-dawn hours of the night, Dorthea Smith and her family would set out for the long drive north to eventually sell their flowers once a week. (Courtesy of the Smith family.)

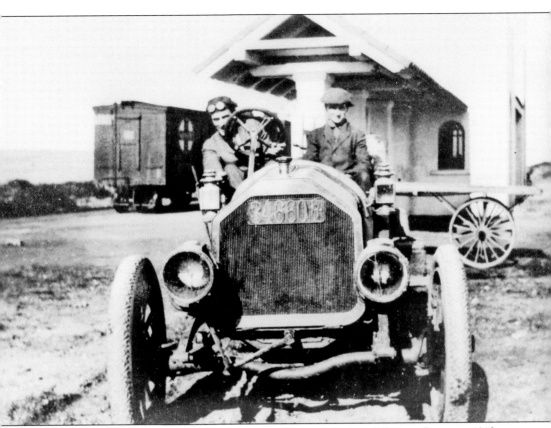

Warner Rathyen (left) and Douglass Satterlee pose in front of the Cardiff Train Depot in 1913. Rathyen, the owner of the Encinitas Garage, proudly drove his Buick Roadster, pictured here. (Courtesy of the Encinitas Historical Society.)

A young Dorthea Smith is enjoying time with her aunt Margaret Meister Armstrong at the beach. As the future matriarch of the Smith family, Dorthea, now 90 years old, continues to enjoy walks along Cardiff's shores. (Courtesy of the Smith family.)

This 1960s photograph shows the residential area now known as Poinsettia Heights. Before track housing, the land was dotted with individual family homes that were designed with beachfront living in mind. (Courtesy of Shirley Schroeder.)

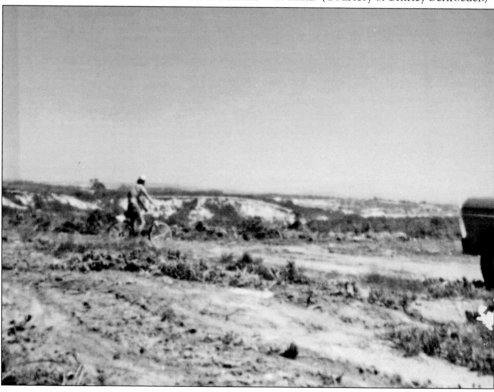

Bill "Red" McChesney and his younger sister, Betty Anne, play a game of tennis at Glen Park in 1928. (Courtesy of Rosann Drielsma.)

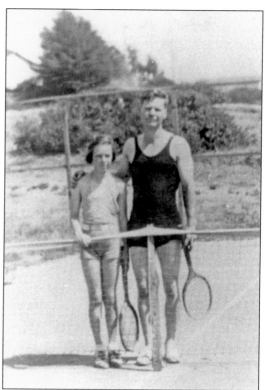

Dorthea Smith and her mother, Rose Clark Miller, sit surrounded by gladioluses. The family initially moved to Cardiff to grow the flowers in the arid climate. (Courtesy of the Smith family.)

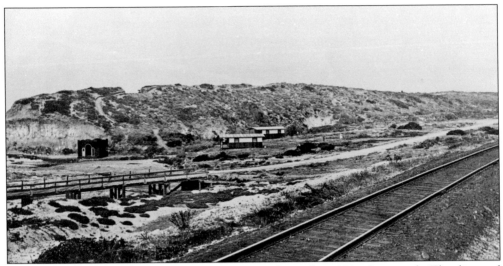

Two unidentified buildings sit next to the train tracks in this 1920s photograph. The dirt road allowed horse-and-buggy travelers to traverse the north and south route from Cardiff to San Diego for trade and labor purposes. (Courtesy of Jay Williams.)

Dorthea Smith at age eight proudly shows off the gladioluses her family grew. (Courtesy of the Smith family.)

Three

A COMMUNITY TAKES SHAPE

Cardiff became a destination for people seeking a tight-knit community to raise children, start a business, and live in close proximity to the ocean. With a steady stream of newcomers, the years between the 1920s and 1950s saw a boom of housing and infrastructure development.

The children of Cardiff walked easily from their homes to the beach and school, the only real fear being the passing trains. An elementary school and a high school were built to accommodate the increasing number of children in families moving to the area.

The town's only industry, a kelp processing plant, was constructed to fill the increasing need for gunpowder during World War I. After the war ended, demand plummeted and the plant was disassembled.

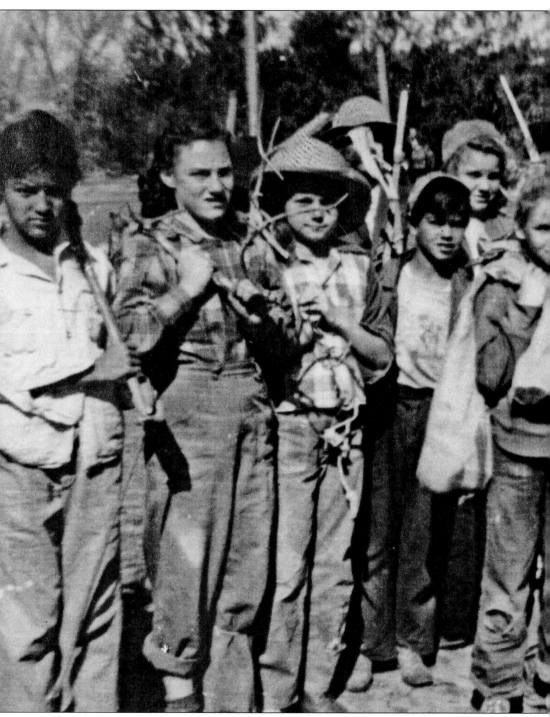

The infamous "Hobo Days" at the Cullen School continued as a tradition at the newly constructed Cardiff Elementary School. Children dressed as hobos, taking their lunches to school in sacks

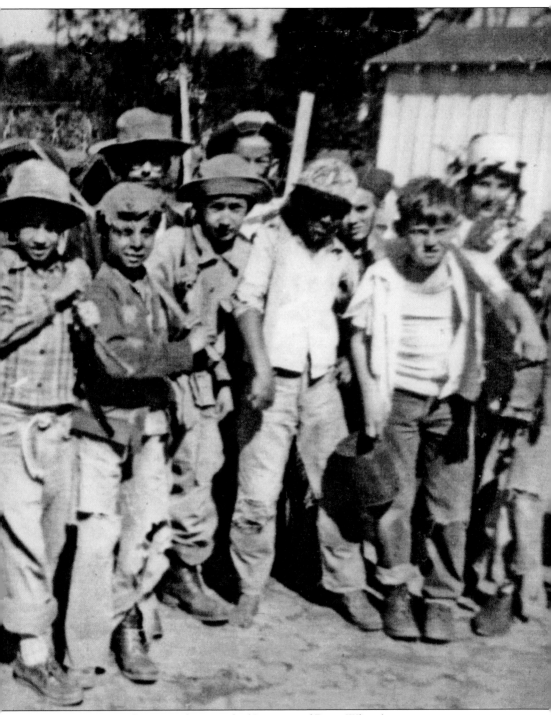

tied to sticks, as seen in this 1948 photograph. (Courtesy of Doug White.)

Cardiff Elementary School officially replaced the Cullen School in 1950 on land donated by J. Frank Cullen. Smith Construction built the school in less than six months at a price far below market rates to ensure the safety of the four Smith children attending the school. (Courtesy of the Smith family.)

This 1925 photograph depicts a magical time in the lives of the Clark-Miller family. A young Dorthea (Clark) Smith is pictured at far left with her stepbrothers Ken, Howard, and John Miller with her aunt Margaret Meister Armstrong (back left) and mother, Rose Meister Clark Miller. (Courtesy of the Smith family.)

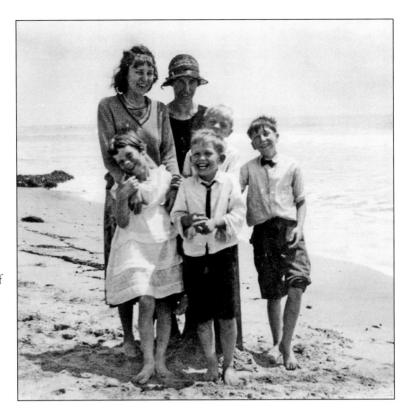

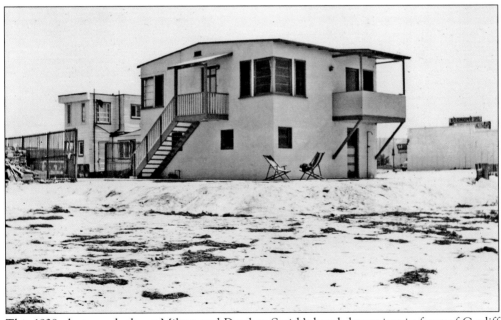

This 1938 photograph shows Milton and Dorthea Smith's beach house just in front of Cardiff Lodge, where rooms were rented on a long-term basis. (Courtesy of the Smith family.)

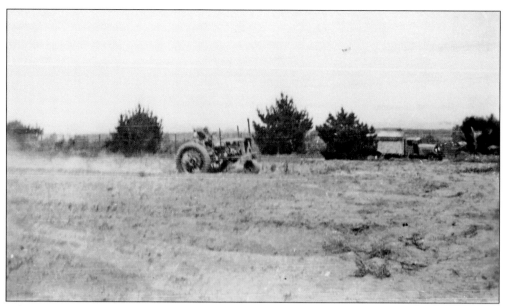

A lone tractor plows the land along Balour Drive in preparation for growing gladioluses. The area still has a number of small greenhouses but pales in comparison to the 1930s and 1940s, when flower growers provided the backdrop of Cardiff. (Courtesy of the Smith family.)

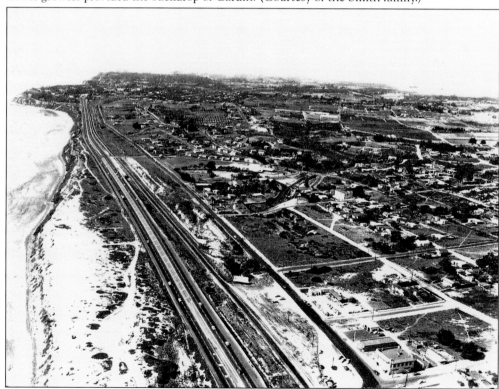

This 1950s aerial photograph shows a pre-campground Cardiff with dunes along the beach that children used as slides. The close-knit community was on the verge of a massive housing expansion but is shown as a sleepy hamlet from above. (Courtesy of Billy Stern.)

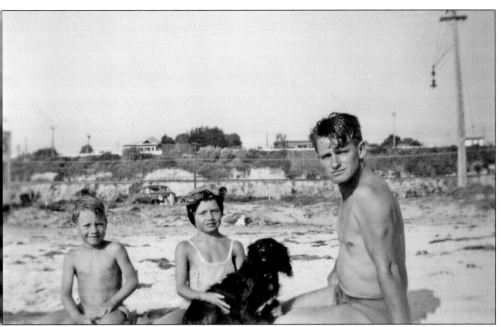

The White family is enjoying a day at the beach with their faithful canine companion in the early 1940s. The area's beaches are more regulated now with ordinances prohibiting dogs. (Courtesy of Doug White.)

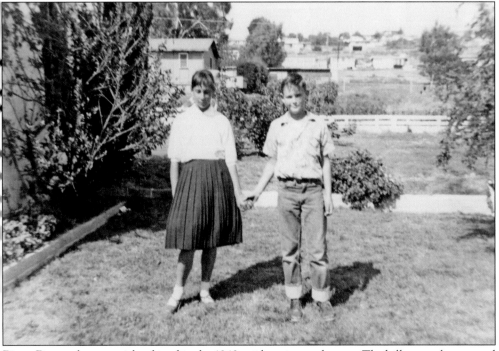

Diane Darrough poses with a friend in the 1940s with a view to the east. The hills are only scattered with homes surrounded by large front and backyards. The current landscape is much more densely populated with more uniform housing structures. (Courtesy of Shirley Schroeder.)

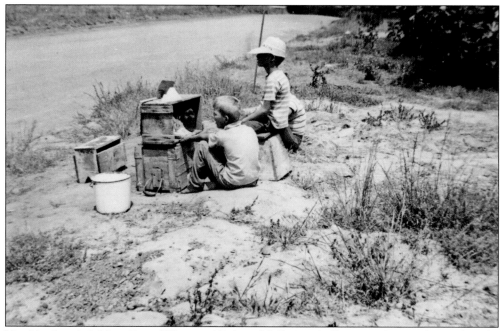

Neighborhood children Doug White and Bob and Billy Mitchell set up a lemonade stand at the intersection of Dublin and Newcastle Streets in the late 1940s. Passersby were more likely to be on foot than driving the dirt roads of the small town. (Courtesy of Doug White.)

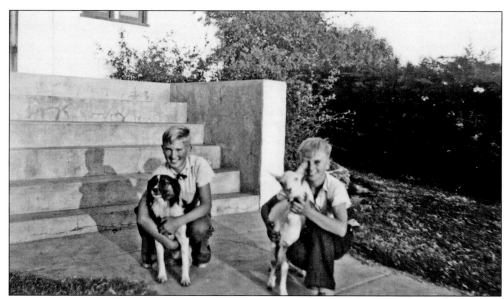

Jay Williams (left) crouches with the family dog Max and his brother Earl "Babe," holding the family goat, in this 1930s photograph. Their mother served as the postmistress for a time; Jay remembers being sent to catch the mailbag from the southbound train as it raced through Cardiff without slowing down. (Courtesy of Jay Williams.)

Six-year-old Rosemary Smith has a laugh on her grandmother Mamie (Mary) Crowley's barbeque behind her restaurant, Frankie's, on the beach in Cardiff around 1945. (Courtesy of the Smith family.)

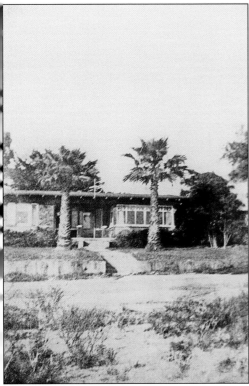

Milton and Dorthea Smith rented this house on Edinburg Avenue for $18 a month just after their marriage in 1937. The house was owned by the Cullen family and provided a space for the newlyweds to call their own. (Courtesy of the Smith family.)

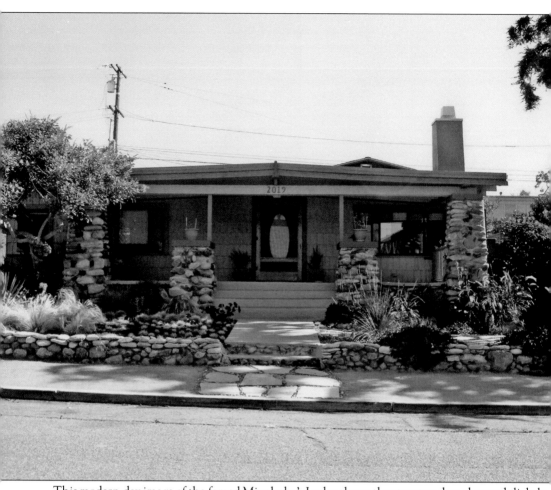

This modern-day image of the famed Minehaha's Lodge shows the structure has changed slightly over the last century. The changes are most striking in the development of the area around the house, where the McChesney family began raising a family in 1924. Matriarch Annie Bea raised chickens behind the house for decades. Members of the community today can still recall buying eggs at "Grandma" McChesney's house. (Courtesy of Rosann Drielsma.)

This late-1940s photograph illustrates the imaginative costumes of the students at the Cullen School during "Hobo Days." Students and teachers joined together to dress and act the part of a hobo, which often including rubbing as much dirt on their faces as possible. (Courtesy of Doug White.)

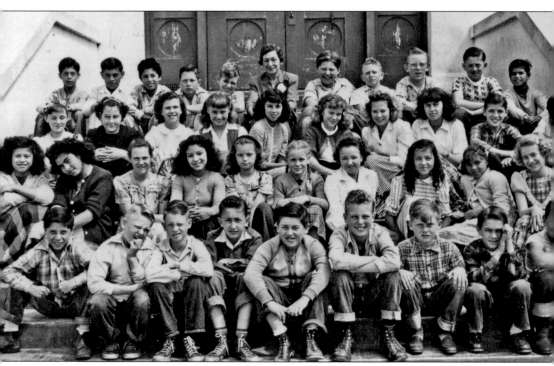

This 1948 class photograph shows fifth and sixth graders at the Cullen School. Ada Harris is pictured at the top center donning her spectacles and a corsage. (Courtesy of Doug White.)

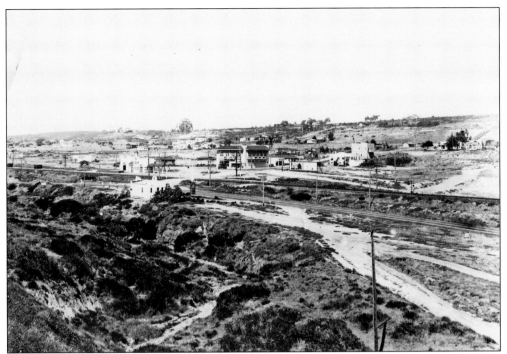

This 1930s photograph conveys the rural landscape of early Cardiff. With only a few commercial buildings and as many residences, the area was easy to miss on the road from San Diego to Oceanside. (Courtesy of Jay Williams.)

Bill "Red" McChesney is pictured second from the right along with other school bus drivers in 1923. High school students as far south as Del Mar were transported to Oceanside each day until 1936, when the San Dieguito Union High School opened in Cardiff. (Courtesy of Rosann Drielsma.)

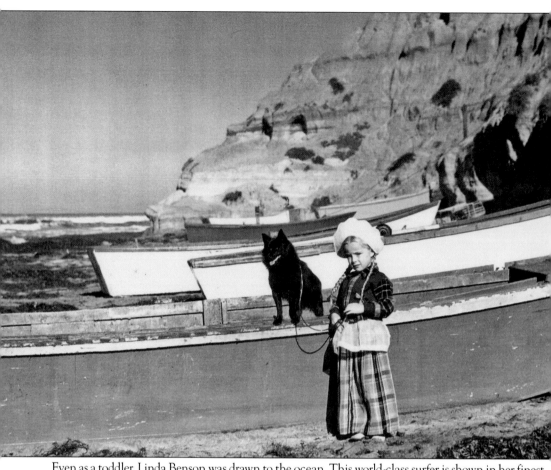

Even as a toddler, Linda Benson was drawn to the ocean. This world-class surfer is shown in her finest attire in a late-1920s photograph with her faithful companion. (Courtesy of Linda Benson.)

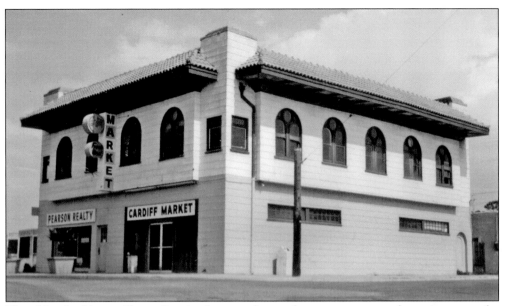

The oldest building still standing in the town has undergone many transformations over the years. In this 1950s photograph, the Mercantile Exchange housed a market and a real estate office. (Courtesy of Doug White.)

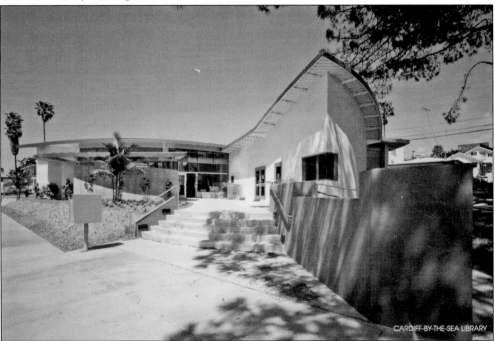

The San Diego County Library system opened the first Cardiff Library in 1914 in response to a petition signed by 38 residents on December 24, 1913. The modest library opened in S. M. Holbrook's Grocery at the corner of Chesterfield Drive and San Elijo Avenue on March 18, 1914. In the 1980s, much like generations before them, a group of committed Cardiffians set out to expand the library in a new location. Two decades later, their dream was realized when a state-of-the-art facility was opened in March 2003. (Courtesy of Billy Stern.)

Taken in 1942, this photograph shows toddler Rosemary Smith with her paternal grandmother, Mary Crowley. Referred to as Mamie by her grandchildren, the entrepreneurial matriarch had her hands in numerous business and development ventures in early Cardiff. (Courtesy of the Smith family.)

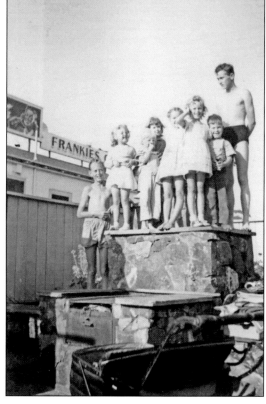

In 1945, children crowded the back barbeque pit of Mamie's restaurant, Frankie's. The hamburger shack, located on the north side of where the Beach House now stands, was popular with the locals. Rosemary was a frequent worker at the restaurant in her youth. (Courtesy of the Smith family.)

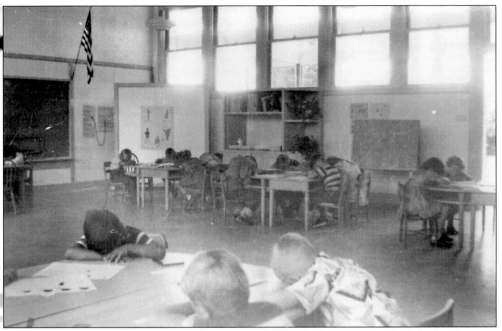

Nap time at the Cullen School for these first-graders in the late 1940s included a brief rest on the desk before getting back to the "three Rs"—reading, writing, and arithmetic. (Courtesy of Shirley Schroeder.)

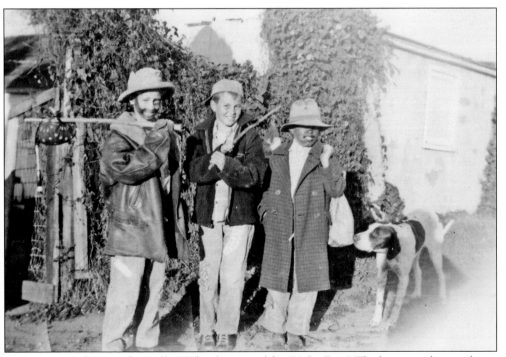

Elementary students at the Cullen School prepared for "Hobo Day." The long-standing tradition of dressing up as a hobo and bringing your lunch to school in a sack tied to the end of a stick was a community affair—even the family dog was invited. (Courtesy of Doug White.)

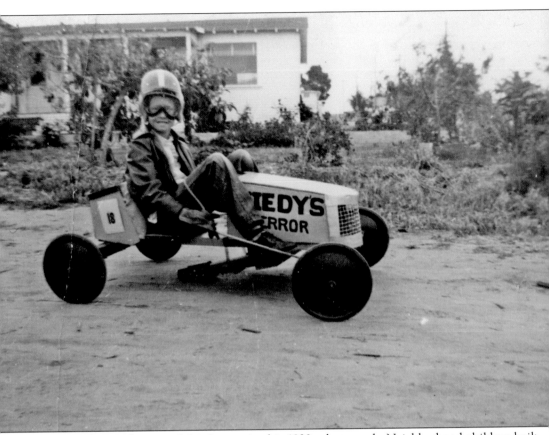

Doug White is shown with his boxcar in this 1930s photograph. Neighborhood children built their own cars to race down the hill from the top of Birmingham Avenue to the finish line at the bottom. White's car, "Tedy's Terror," was even sponsored by a local merchant. (Courtesy of Doug White.)

Ada Harris, donning an apron in this late-1940s photograph, served as the Cullen School's principal for many years even after the name changed to Cardiff Elementary. A second school was named in her honor in 1958. (Courtesy of Doug White.)

The Girls Athletic Association was only available to those who could withstand the gauntlet of initiation, which included eating a raw onion as if it were an apple and having flour and honey poured on them. Thirteen-year-old Rosemary Smith made the cut in the exclusive San Dieguito Union High School club that included putting on events such as the annual Mother-Daughter Tea and Fashion Show. (Courtesy of the Smith family.)

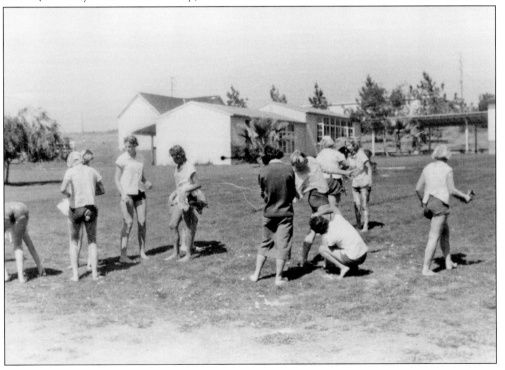

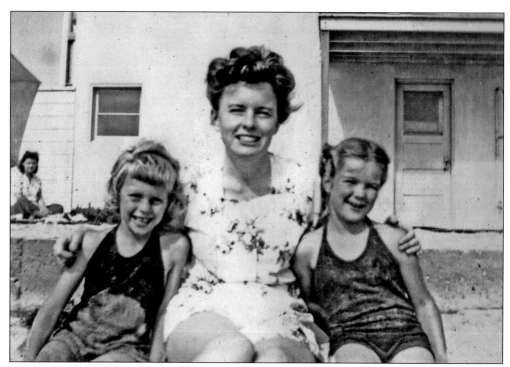

Dorthea Smith with her daughters Donna (right) and Rosemary (left) enjoyed a day at their beach house in 1945. The Smiths bought the property where the Beach House restaurant now stands in 1938. The lot was 40 feet wide along Coast Highway 101 and 200 feet deep to the mean high-tide line of the Pacific. The area between the house and the ocean was used to park the family's trucks and store a gas tank. (Courtesy of the Smith family.)

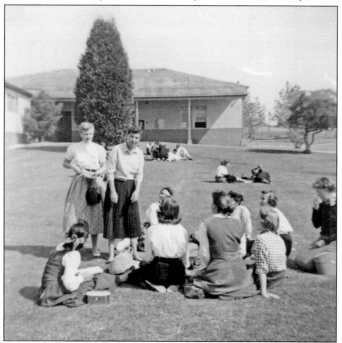

This 1957 photograph shows the senior lawn filled with students relaxing at San Dieguito Union High School. The school, now called San Dieguito Academy High School, was established in 1936 and now occupies a 10-acre parcel along Santa Fe Drive. (Courtesy of the Smith family.)

This 1936 photograph shows Milton Smith and nephew Bob Babicky at the family beach house behind the current restaurant row in 1936. (Courtesy of the Smith family.)

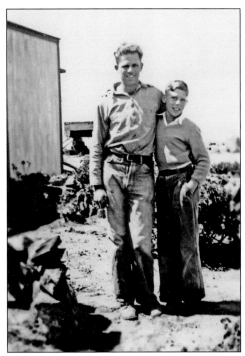

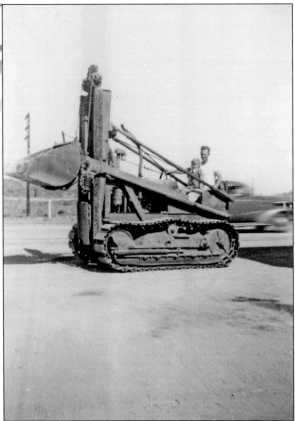

One of the many pieces of heavy machinery used by Smith Construction Company to develop the infrastructure of Cardiff is seen in this 1940s photograph. The business had a rock and sand plant and a fence department and provided general construction services. The company was the largest employer in Cardiff in 1950. (Courtesy of the Smith family.)

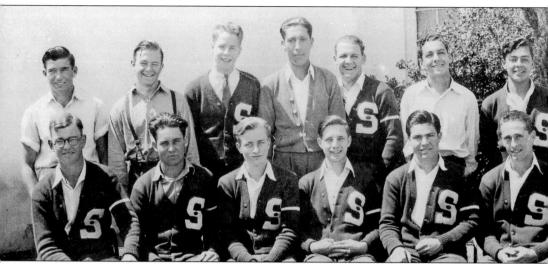

Members of the first graduating class of the San Dieguito Union High School in 1937 pose for a picture. The new local high school allowed students to forgo the long commute to Oceanside for classes. Tents were purchased for $10 each from the Los Angeles School District to house the students before proper classrooms could be built. (Courtesy of the Encinitas Historical Society.)

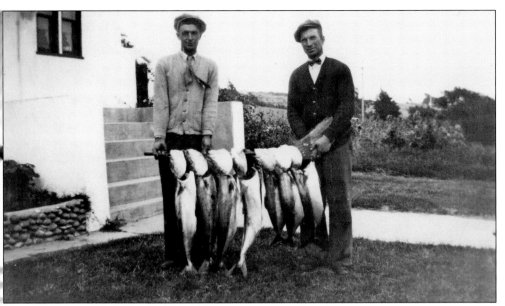

Fish were plentiful in the 1930s Depression era. This photograph shows a good day's catch by the Williams family. (Courtesy of Jay Williams.)

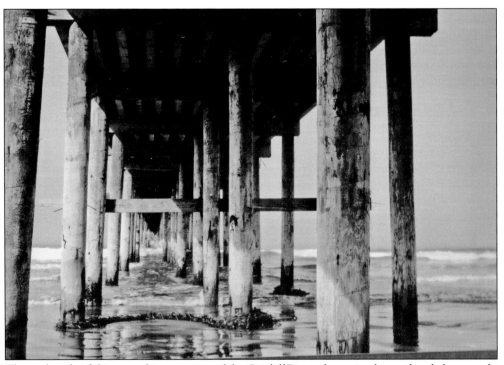

The underside of the second incarnation of the Cardiff Pier is shown in this undated photograph. Despite the high hopes of the residents, the pier never amounted to more than an eyesore before its removal shortly after construction. (Courtesy of Doug White.)

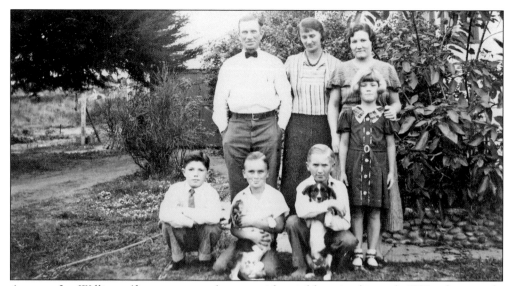

A young Jay Williams (first row, center) poses with neighbors in this early-1930s photograph. Williams recalls fields of sagebrush and poppies filling the expanse of land surrounding his family home on Montgomery Avenue. The longtime teacher, now retired, built his current home less than a block away from where he grew up. (Courtesy of Jay Williams.)

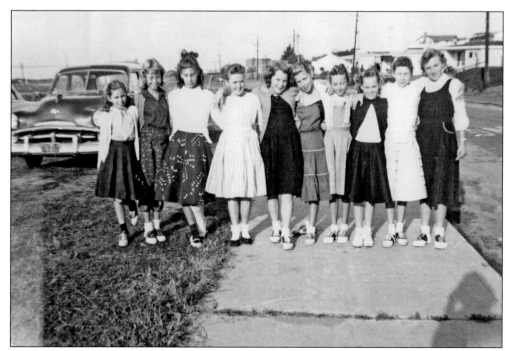

In 1953, a group of tight-knit sixth-grade friends pose for a picture. The girls were always dressed in the latest fashion, donning bobby socks and poodle skirts. (Courtesy of Shirley Schroeder.)

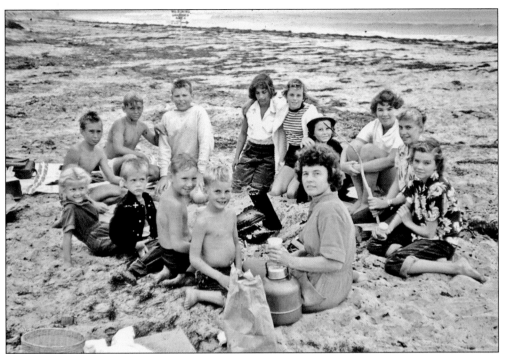

Dorthea Smith brought together a group of sixth graders known as the "Cardiff Characters" who went on outings together. This beach party in 1951 included the Smith children—Donna, Rosemary, David, and Tricia—along with several neighborhood friends. (Courtesy of the Smith family.)

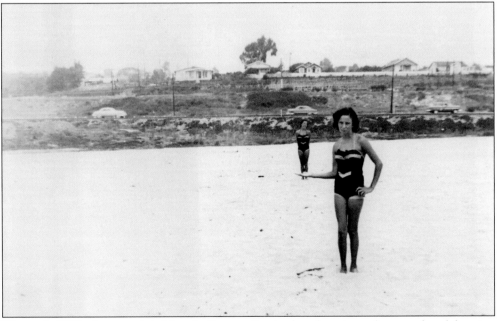

This early-1950s photograph is historically revealing in that there is an absence of track housing above the cliffs behind the beach. Unlike today's Cardiff, the hills were still sprinkled with individually designed bungalows. The artistic photograph, which appears to have one woman holding a smaller woman in her hand, is just fun. (Courtesy of Shirley Schroeder.)

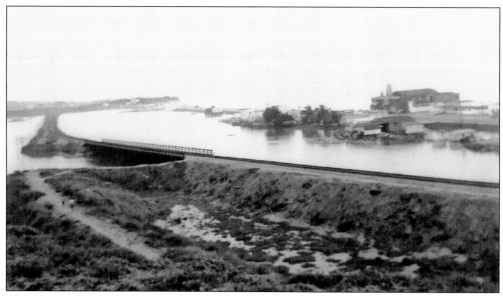

The constant flooding of San Elijo Lagoon wreaked havoc on the Coast Highway 101 transportation corridor. This early-1950s photograph shows the impassable two-lane roadway. (Courtesy of Doug White.)

The view from Edinburg Avenue in 1932 offered a scenic Cardiff. The lone stretch of undeveloped land has power lines running through in anticipation of increased demand for electricity by commercial enterprises and homes. The area is now a densely populated residential neighborhood. (Courtesy of the Smith family.)

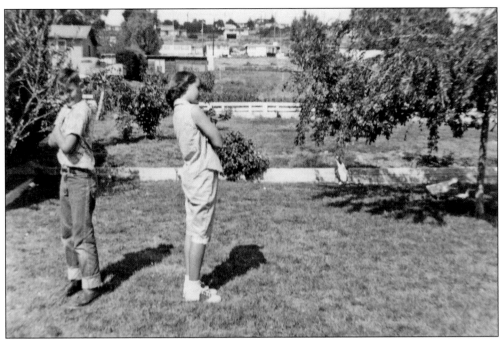

This mid-1950s photograph of Shirley Schroeder and a friend in her grandmother Lillian Schroeder's front yard shows the encroaching development and growth of Cardiff. Although lot lines were separated by a larger expanse than today, the area was becoming more densely populated. (Courtesy of Shirley Schroeder.)

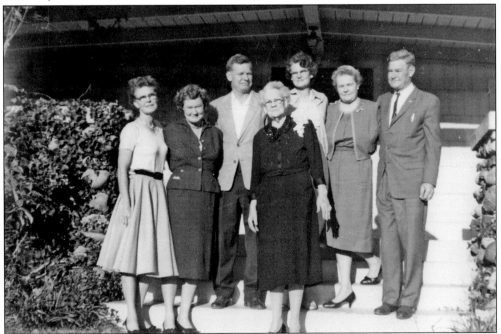

Grandma (Annie Bea) McChesney poses with her family for a photograph in the early 1950s on the steps of the house at 2019 Manchester Avenue. While it was referred to as Minehaha's Lodge, it also came to be known as the Stones House of Cardiff to some. (Courtesy of Rosann Drielsma.)

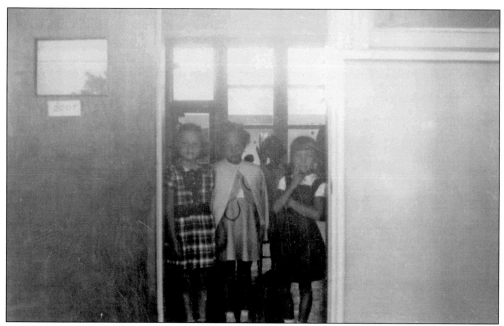

First-grade students at the Cullen School in the mid-1940s take a peek outside the classroom. Two decades earlier, the Cardiff Mothers group—a predecessor of the modern parents' association—was made famous for making hot lunches for the students during the Depression era. (Courtesy of Shirley Schroeder.)

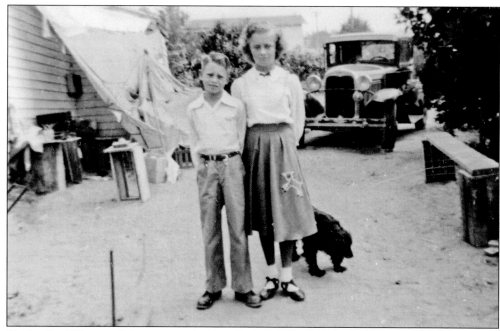

Shirley Sue White, with her younger brother Doug, poses in a fashionable poodle skirt and bobby socks in the early 1950s. (Courtesy of Doug White.)

The seemingly inconspicuous house along San Elijo Avenue was never home to anyone. Rather, it was used during World War II as a telephone communications center. According to locals, government attempts to disguise the real purpose of the building from Japanese bombers that might have been flying off the Pacific coast with faux doors and windows actually made it stand out even more. Without another house around for miles, the "old phone building" was a target for ridicule if not for air raids. Today the building stands idle next to Cardiff Elementary School. (Courtesy of Doug White.)

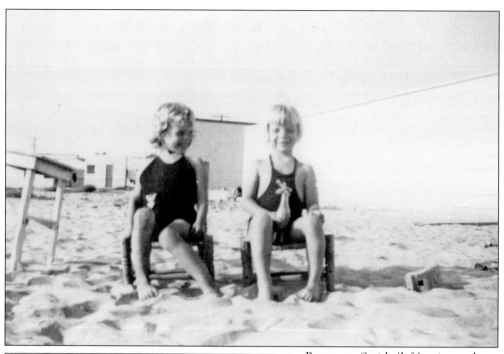

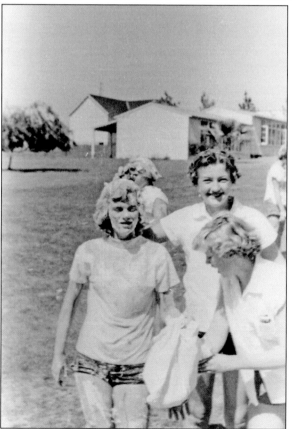

Rosemary Smith (left) enjoys a day
at the beach with her cousin Cathy
Meister, who visited frequently from
the Los Angeles Area. The two girls,
just months apart in age, enjoyed
the desolate beach playground
in front of the family home.
(Courtesy of the Smith family.)

The Girls Athletic Association,
or the GAA as it was called by
those in the know, initiation
at San Dieguito Union High
School in 1952. A 13-year-old
Rosemary Smith was covered with
flour and honey in the process
of becoming "one of the girls."
(Courtesy of the Smith family.)

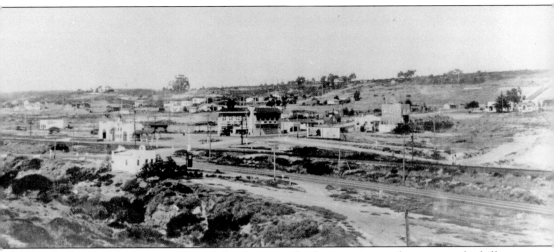

This 1930s photograph shows residential development slowly emerging to the east, up the hill that overlooks the Pacific. The train depot is still present, and the Mercantile Building is ringed with elegant balconies that are no longer present. (Courtesy of Rick Mildner.)

Cullen School principal Ada Harris is seen in this early-1950s photograph participating in the "Hobo Day" tradition. Her usual impeccable dress suspended for the day, Harris helped the elementary students build fire pits the week before the event and play games. (Courtesy of Doug White.)

This early-1940s photograph shows, from left to right, Shirley Sue and Doug White with their friend "Flap" Jackson preparing to walk to the beach. With glass bottles in hand to aid in making sand castles, the children enjoyed the freedom of a small-town atmosphere where the biggest concern of parents was that their children stay clear of oncoming trains. (Courtesy of Doug White.)

Four

CHANGING LANDSCAPE
FROM KELP TO DOUGHNUTS

Cardiff began its modern growth after World War II. With a rapid pace, the area expanded into previously uninhabited land. The Poinsettia Heights development in the late 1950s brought an additional 1,700 residents to the coastal community. A new interstate was built, expanding the flow of traffic to the east as flooding destroyed large areas of Coast Highway 101 along the Pacific. Infrastructure was shored up to diminish the eroding coastline, and a state campground was built, taking a large swath of cliffs and sand dunes from the backdrop of Cardiff.

Surf spots from Seaside to Swami's became more crowded with visitors, marking Cardiff as a sought-after destination on the map. Locals continued to meet at the unofficial city hall—VG Donuts—to discuss the changing landscape.

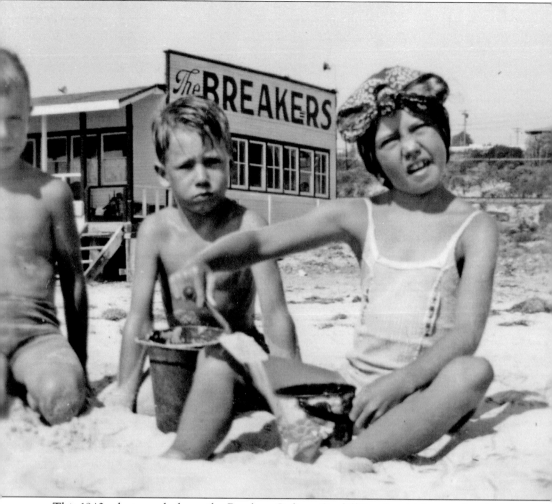

This 1940s photograph shows the Breakers Café on Cardiff Beach, which served up burgers in a basket to hungry beachgoers. The area was also the site of the Cardiff pier that held a perpetual motion machine. Around 1915, the 300-foot-long pier had what appeared to be an oversized lobster trap attached to the end in an effort to harness wave action to be converted into energy. The pier, along with the unusual machine, was destroyed in the great storm of 1916, according to historical documents. (Courtesy of Doug White.)

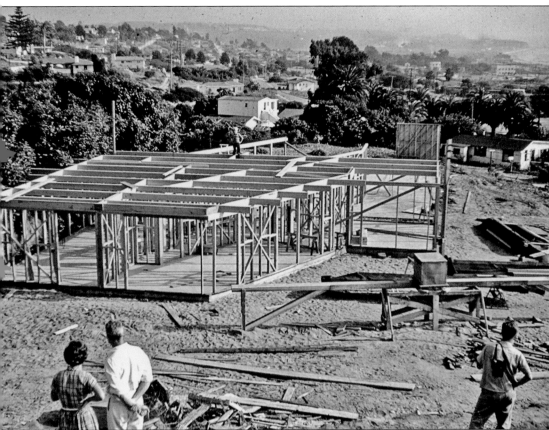

Dorthea Smith and her dear friend Austin Faricy surveyed the progress of the construction of her family house. The intricate details of the house added to the length of time it took to build the house. From 1950 to 1953, the family waited in anticipation of their new home. Although the second floor was not complete and there was no heat, the family happily arrived at the spacious, modern architecture. (Courtesy of the Smith family.)

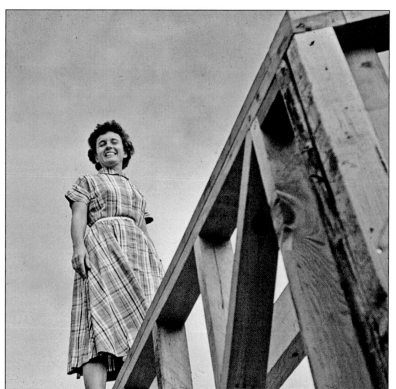

Dorthea Smith is on top of the scaffolding of her dream home at 1745 Rubenstein Drive. The house sat high atop the Pacific Ocean overlooking the Cardiff landscape, where much of the infrastructure was built by Smith and her husband, Milton. (Courtesy of the Smith family.)

An unidentified young man poses for the camera in this early-1950s photograph. The "Point" behind him was taken down to make way for the campground some 20 years later. Notice the Mercantile Building behind the towering cliff. (Courtesy of Shirley Schroeder.)

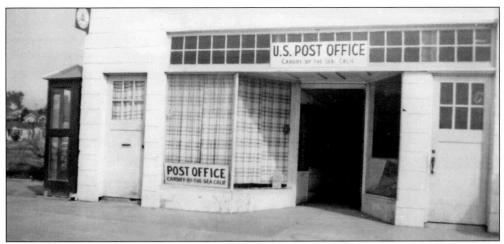

The Cardiff Mercantile Building housed the post office at the corner of San Elijo Avenue and Chesterfield Drive from 1911 until the mid-1950s. Many residents remember as kids in the early 1930s filling in for the postmistress when she was sick or away on vacation—the train would slow down enough for the conductor to retrieve the hanging outgoing mail bag from a hook attached to the platform. Children were warned to watch out for the incoming mail bag that was thrown from the train simultaneously. (Courtesy of Ken Harrison.)

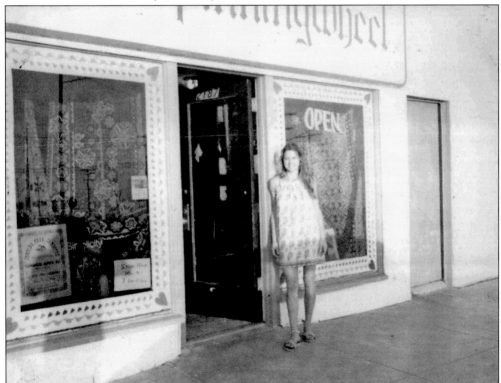

A teenage Diana Brummett poses for this 1960s photograph in front of her workplace—the Spinningwheel—housed in the Cardiff Mercantile building. The fabric shop was one of many businesses to call the town's oldest building home. For years, Patten's Market was the anchor of the small commercial district. (Courtesy of Diana Brummett.)

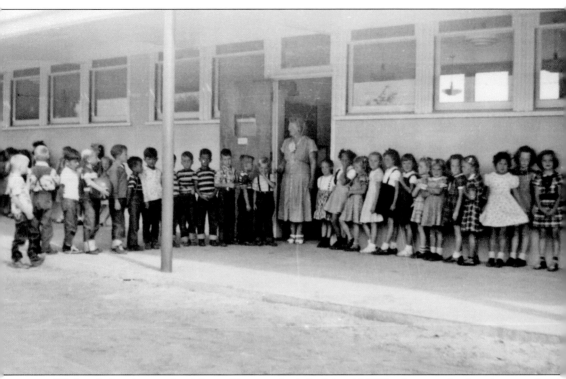

With girls lined up to the right and boys to the left, this mid-1950s photograph of students at the Cullen School shows the early structure of the elementary classroom. Despite it being a beachside community, children were expected to adhere to a proper dress code as part of the educational experience. (Courtesy of Shirley Schroeder.)

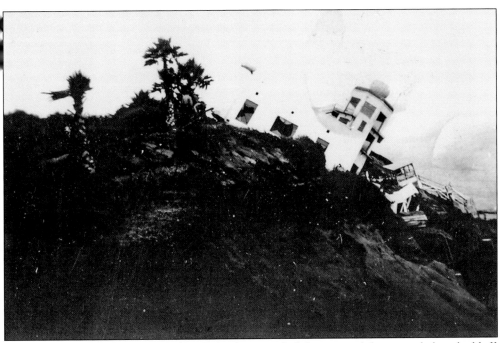

The Lotus Temple can be seen in this 1940s photograph sliding toward the ocean below the bluff. Located at the northernmost edge of Cardiff, the point is referred to as Swami's, where another temple and meditation garden was erected. (Courtesy of Jay Williams.)

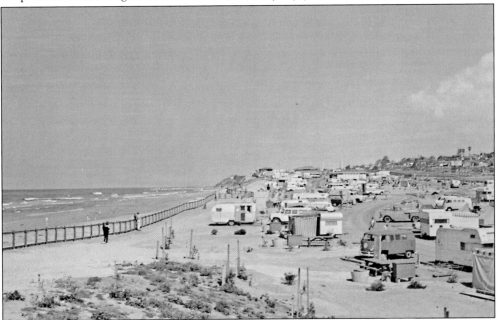

Cardiff State Beach Campground is an extremely popular attraction with waits of up to one year for a camping spot overlooking the ocean. Acquired by the County of San Diego from the Santa Fe Irrigation District in 1938, the parcel was deeded for state use in 1949. Other acquisitions have increased the acreage, which now has approximately 4,000 feet of ocean frontage bordering Coast Highway 101. (Courtesy of Ken Harrison.)

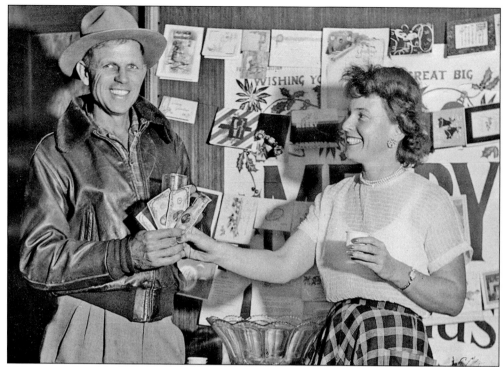

Milton and Dorthea Smith celebrated a successful year at the annual Smith Construction Company holiday party in the early 1950s. Another person was added to the payroll and a loan was paid off to put the family-run company in the black. Dorthea surprised Milton with $1,000 bills ordered special from the bank. The rare bills are no longer in circulation. (Courtesy of the Smith family.)

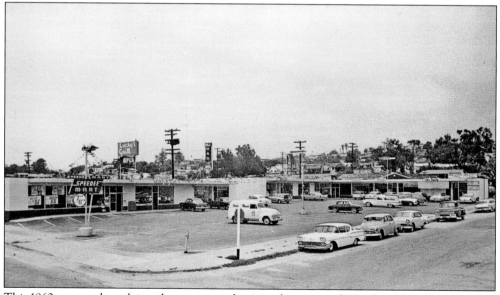

This 1960s postcard proclaims the commercial strip at the corner of Aberdeen Drive and San Elijo Avenue as "A Modern Shopping Center." Anchored by a Speedee Mart, the center did brisk business in the town with a population of approximately 2,000 people. (Courtesy of Ken Harrison.)

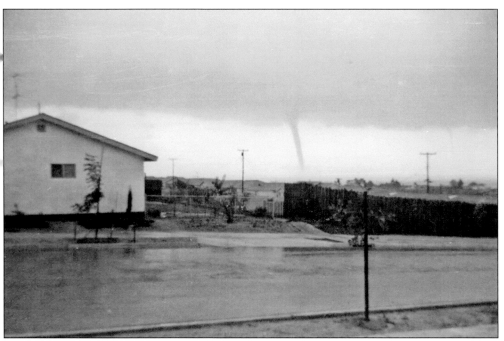

Waterspouts in the Pacific Ocean off the Cardiff coast startled onlookers in 1962. The uncharacteristic stormy weather and tornadoes continued throughout the day. (Courtesy of Ken Harrison.)

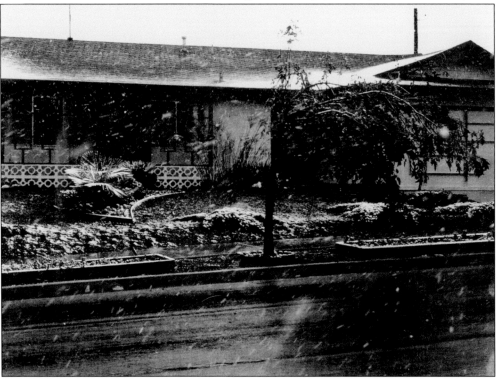

Snow lightly blanketed the town in 1967, to the delight of children and adults alike. The magic quickly faded as the 2 inches of powder melted by noon. (Courtesy of Ken Harrison.)

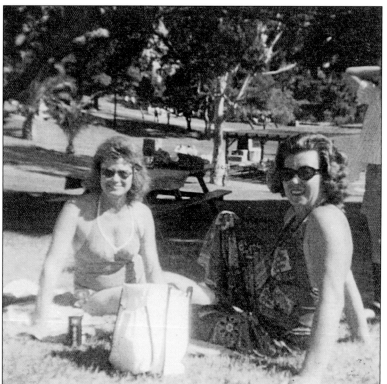

Irene Brummett (left) and Mae Lewis picnic at Glen Park in the early 1970s. The matriarchs headed two families steeped in the history of Cardiff's water culture. The park is surrounded by a neighborhood with the railroad tracks bordering just to the west. (Courtesy of Tommy Lewis.)

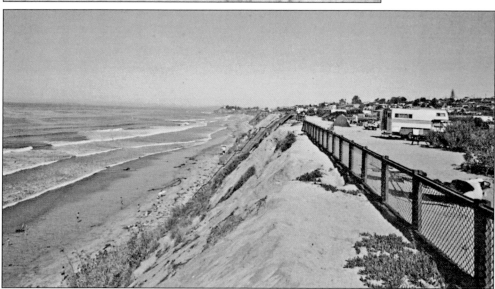

In January 1966, ground was broken on the construction of a 171-unit campground just north of the mouth of the San Elijo Lagoon. In less than a year, phase one was complete and the facility opened to the public at a cost of $756,300. While the state-operated campground delighted visitors with affordable accommodations right on the beach, many residents lamented the intrusion and the removal of large sections of existing bluff. However, unlike other oceanfront bluff-top communities in Southern California, Cardiff was saved from development that could have blocked views of the Pacific and limited access to the beach. (Courtesy of Ken Harrison.)

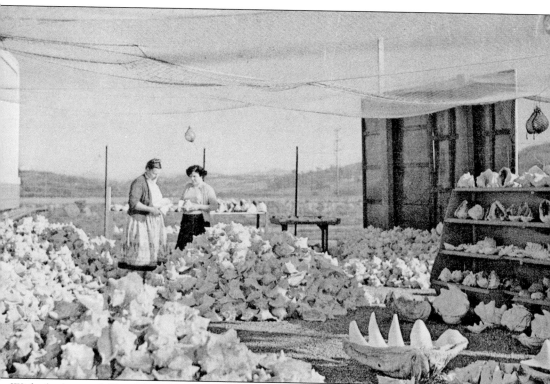

With the barren hills of Cardiff and the tranquil beauty of the San Elijo Lagoon as a backdrop, the Vincent Shell Shop boasted itself the "largest sea shell yard on the Pacific Coast." Shown in the mid-1960s, this local landmark offered all manner of dried sea creature kitsch in the spot where the restaurant Las Olas now stands. (Courtesy of Ken Harrison.)

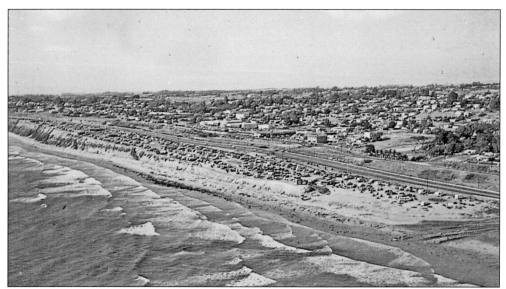

This undated postcard shows increasing residential development on the hills overlooking the ocean. The crowded seaside campground is visible in the foreground. (Courtesy of Ken Harrison.)

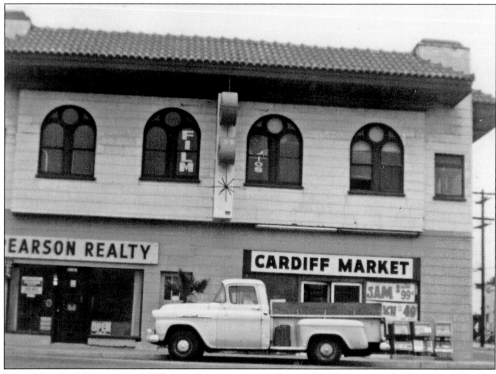

The oldest building in Cardiff, located at the corner of San Elijo Avenue and Chesterfield Drive, has housed various businesses over its storied history. In this 1950s photograph, the once decorative architecture has been stripped to the bare necessities of a grocery market and real estate business. Although it has never been restored to its previous grandeur as the Cardiff Mercantile Building of the late 1800s, the building has stood the test of time and punctuated surrounding commercial developments. (Courtesy of Doug White.)

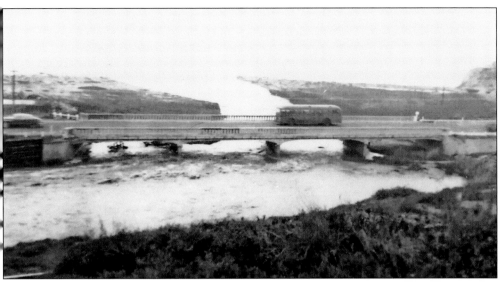

In this undated photograph, a school bus heads south over the bridge as the San Elijo Lagoon makes its way to the Pacific Ocean. The fragile watershed is now part of San Elijo Lagoon Ecological Reserve, a county and state regional park of nearly 1,000 acres of diverse habitat. (Courtesy of Doug White.)

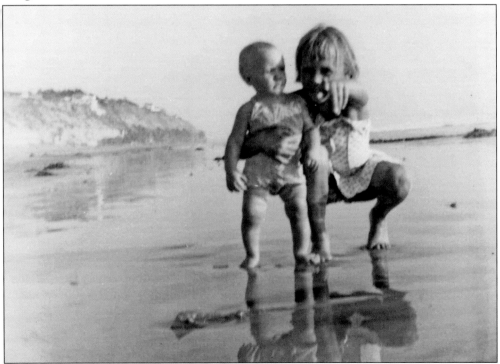

Diana Brummett, with her little sister Shaunda, shows the view looking south toward Solana Beach in this 1950s photograph. The towering cliffs have since eroded significantly, as runoff from residential and commercial development along with infrastructure improvements to accommodate the increasing traffic has expedited the natural process of bluff erosion. (Courtesy of Diana Brummett.)

This 1951 photograph shows one-year-old Dan Dalager at his family's home in Cardiff. The lifelong resident served as mayor of Encinitas after the city was incorporated in 1986, including the community of Cardiff into the fold. He continues to serve on the city council and has since moved to the community of Leucadia. (Courtesy of Dan Dalager.)

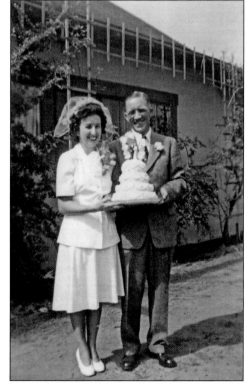

Hans and Valero Dalager celebrated their marriage on October 5, 1946. The newlyweds, both marines in active service during World War II, were married in the Cardiff Methodist Church at the corner of Birmingham Drive and Manchester Avenue. The church, a center of activity dating back to the 1920s, merged with another nearby congregation in 1968 to form San Dieguito United Methodist Church in Encinitas. (Courtesy of Dan Dalager.)

Bill and Irene Brummett migrated from Minnesota to raise a family in the more favorable climate of Cardiff. Their children—Dennis, Gary, Billy, Shaunda, and Diana—grew up on Liverpool Drive, where the couple bought a house, as seen in this early-1950s photograph, in 1951 for a mere $19,000. The area now commands some of the highest home prices in the county. (Courtesy of Diana Brummett.)

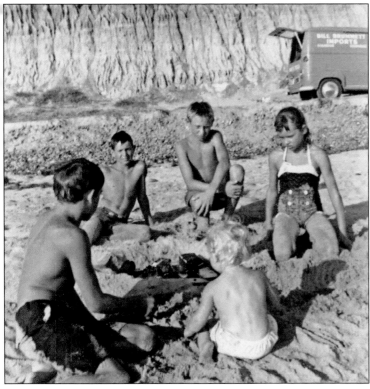

The Brummett children staked their spot on the beaches of Cardiff regularly, as shown in this early-1950s photograph. Campfires and swimming were a part of everyday life for the children, who mark the history of the area with the changes in surf breaks, cliffs, and kelp forests. (Courtesy of Diana Brummett.)

85

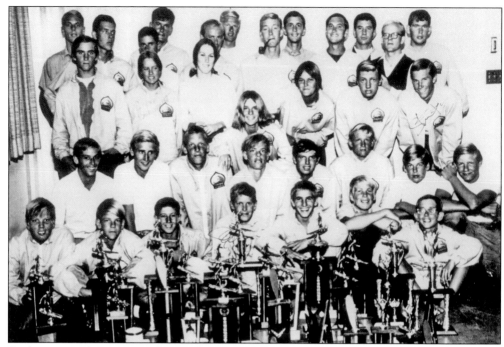

Surfing was and is an integral part of growing up in Cardiff for many children. This early-1960s photograph shows young members of the infamous Swamii's Surfing Association—including Diana, Gary, and Billy Brummett—displaying their trophies won at various competitions throughout California. (Courtesy of Diana Brummett.)

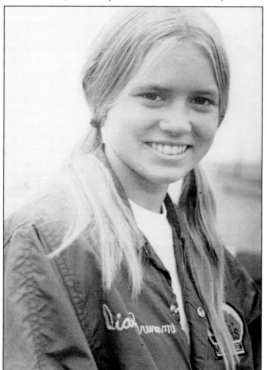

This 1965 photograph shows 13-year-old Diana Brummett wearing her coveted Swamii's Surfing Association jacket. As part of the team, Brummett traveled to numerous competitions in the state and excelled at tandem surfing. She was determined to keep up with her brothers, Gary and Billy, as she regularly hauled her 30-pound longboard from her home on Liverpool Drive several blocks to the beach. (Courtesy of Diana Brummett.)

According to many of the participants, "Hobo Days" was one of their fondest memories of elementary school in Cardiff. Shown in this mid-1950s photograph, children were given freedom to roam the outlying areas of Cullen School where only a few neighboring houses could be seen. (Courtesy of Shirley Schroeder.)

Sisters Shirley (left) and Donna Schroeder posed in their bathing suits with their dog Penny and the family cat for this early-1950s photograph. (Courtesy of Shirley Schroeder.)

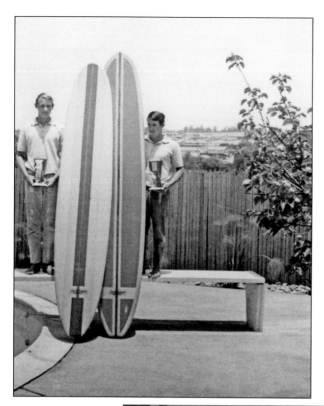

This mid-1960s photograph shows Gary and Billy Brummett standing with their longboards in the backyard of the family home on Liverpool Drive. The brothers often advanced in surfing contests, as evidenced by the trophies they are holding. (Courtesy of Diana Brummett.)

Shirley Sue White, along with her mother, Sue, and younger brother Doug pose in front of their first home in Cardiff on Oxford Street in 1955. While the area was growing, houses remained modest in size. (Courtesy of Doug White.)

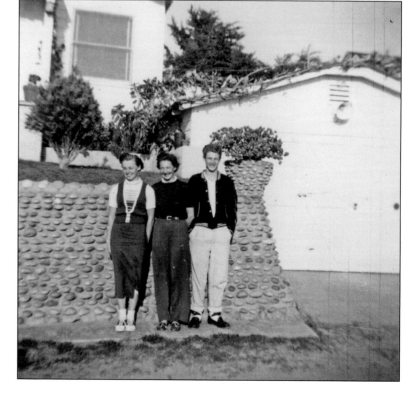

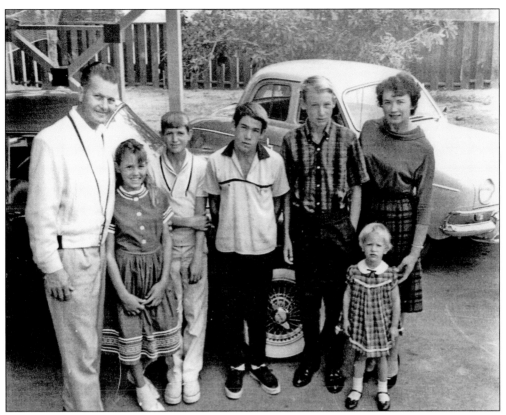

The Brummett family is impeccably dressed in this early-1950s photograph. Most of the time, the children surfed and used the nearby beach as their playground. (Courtesy of Diana Brummett.)

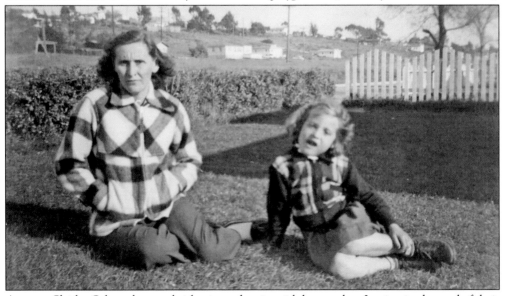

A young Shirley Schroeder on a brisk winter day sits with her mother, Louise, in the yard of their home on Manchester Avenue in this 1948 photograph. The view to the east shows Cardiff's hills were void of significant residential development. (Courtesy of Shirley Schroeder.)

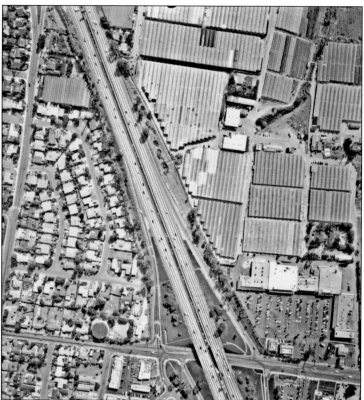

This aerial view of the intersection of Interstate 5 and Santa Fe Drive, Cardiff's border to the north, shows the geographical separation of the traditional agricultural land to the east and the beach community to the west. One significant exception was the 43-acre property owned by flower grower Robert Hall, depicted on the right side of the photograph. The City of Encinitas purchased the land in 2001 to be used as a community park. (Courtesy of Billy Stern.)

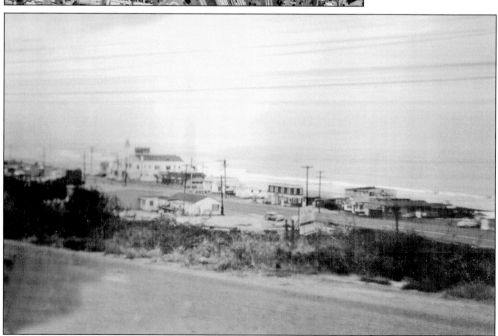

Cardiff's Restaurant Row is shown in this 1950s photograph. The area along South Coast Highway 101 has developed over the years into a thriving commercial district with eating establishments offering stunning sunset views and varied culinary delights. (Courtesy of Doug White.)

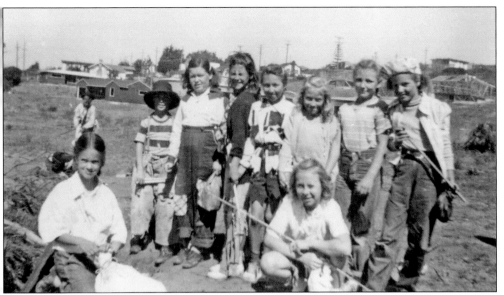

Cullen School students gathered in this late-1940s photograph to show off during "Hobo Days." Schoolchildren usually dug fire pits on the school grounds overlooking the ocean the prior week in preparation for cooking their lunches. (Courtesy of Shirley Schroeder.)

The Schroeder family is shown around the kitchen table in this mid-1940s photograph. Arnold and Lillian migrated from Michigan to settle in the home on Aberdeen Drive that later became Besta Wan Pizza, a restaurant favored by locals. While the front yard was replaced with a parking lot, the house, which turned into the eating establishment, has maintained much of its original character. (Courtesy of Shirley Schroeder.)

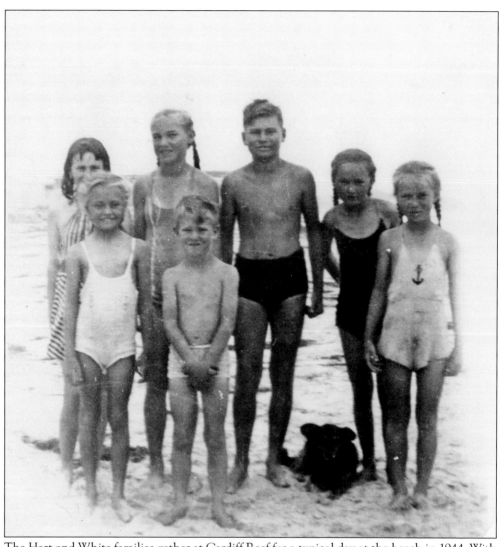

The Hart and White families gather at Cardiff Reef for a typical day at the beach in 1944. With their trusty canine companion in tow, the children often collected rocks and treasure-filled debris carried to the beach from ships far out in the Pacific. (Courtesy of Doug White.)

Doug and Shirley Sue White join their mother, Sue, for a day at one of Cardiff's wide beaches as shown in this early-1940s photograph. The entire community spans only 1.9 square miles, with much of the area overlooking the Pacific coastline. (Courtesy of Doug White.)

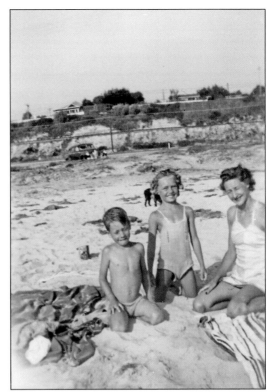

Although Cardiff technically became a community within Encinitas when the city was incorporated in 1986, it retained its own zip code—92007. This 1950s photograph shows the local post office when it was housed in the Mercantile Building. Hometown touches are still evident at the post office according to local historian Irene Kratzer, such as hand-stamping a visitor's postcards bound for Cardiff, Wales, with the sister-city's postmark. (Courtesy of Doug White.)

Recreation was not what the builder had in mind in this 1965 photograph of the Cardiff Pier. Some residents were excited at the prospect of a fishing pier at the reef only to find the temporary construction was taken down less than a year later with little in the way of explanation for its existence. (Courtesy of Doug White.)

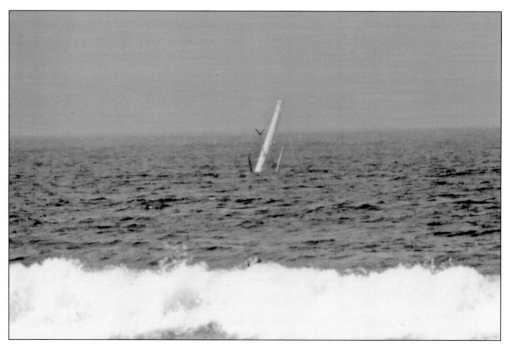

A cement-bottom sailboat took an ill-fated journey off the coast of Cardiff in the early 1970s. Its origins and its destination were unknown to passersby as they viewed the ominous mast rising from the ocean floor. (Courtesy of Doug White.)

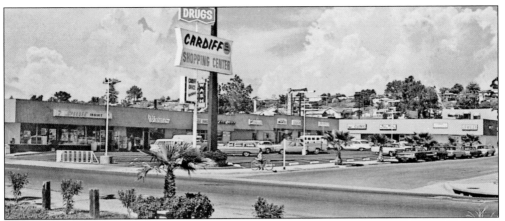

The 1950s brought the development of a thriving shopping center to the corner of Aberdeen Street and San Elijo Avenue. Its most notable tenant, the landmark VG Donuts, is commonly referred to as the Cardiff City Hall, where "decisions are made." Started in 1967 by the Mattee family, the third-generation business is still selling delicious donuts to the public. When the business was initially purchased, no one thought about the name—which happened to be the initials of the former owner's daughter—so they decided to keep it and call it Very Good Donuts. Everyone agrees that the name reflects the quality of the goods. (Courtesy of Ken Harrison.)

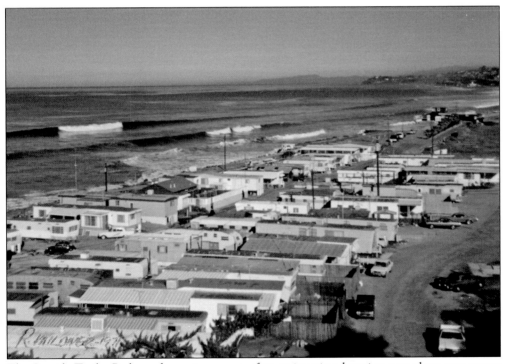

The Seaside Trailer Park was home to many surfers, as its prime location gave them easy access to the reef break at affordable prices. Seen in this 1971 photograph, the modest accommodations were eventually replaced by a state beach facility. (Courtesy of Rick Mildner.)

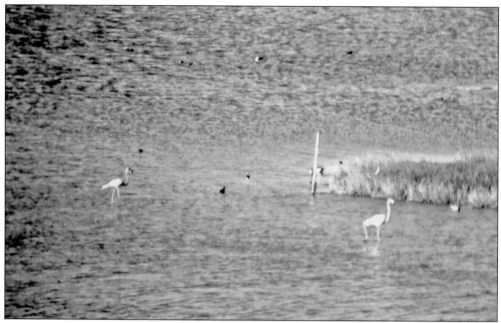

Shown in this early-1980s photograph, flamingos mysteriously appeared in San Elijo Lagoon, setting up camp for a few weeks in the unfamiliar marsh. Residents surmised the animals had escaped from the San Diego Zoo some 25 miles to the south. (Courtesy of Doug White.)

The remnants shown in this undated photograph are all that remain of the Kelp Works plant that was built just east of the railroad tracks on the north side of San Elijo Lagoon in 1911. Large kelp processing boats could be seen off the coast from the Cardiff shores, harvesting the ingredients that were highly sought after during World War I to make gunpowder. (Courtesy of Doug White.)

This mid-1940s photograph shows a dapper young Doug White standing in his family's dirt driveway. The community's infrastructure has remained relatively undeveloped in some areas, with the absence of sidewalks or paved driveways a common occurrence. (Courtesy of Doug White.)

Doug White (left) and his friend "Flap" Jackson are seen in this late-1940s photograph digging trenches in the sand to make way for the outgoing tide of the San Elijo Lagoon. Where the fast-moving waters rush to meet the Pacific, children often ride the rapids and attempt in vain to redirect the tides. (Courtesy of Doug White.)

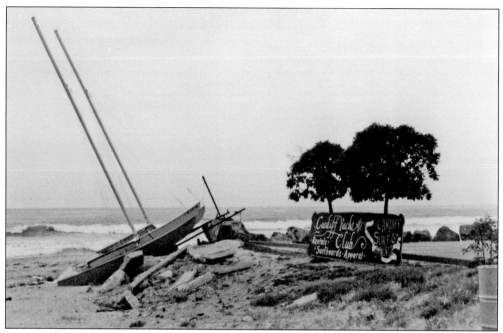

A sign welcoming visitors is seen beside a marooned sailboat along Cardiff's Restaurant Row in this late-1970s photograph. (Courtesy of Diana Brummett.)

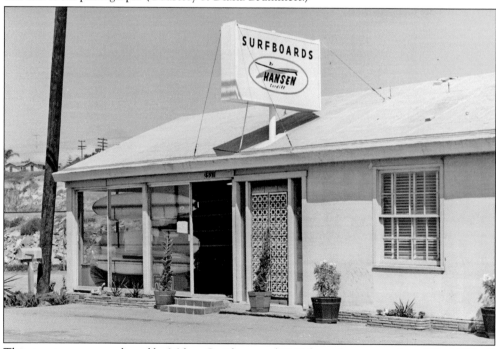

This structure was purchased by Milton Smith around 1945 from the war surplus of World War II for $16. The entire building came to Smith in a box that he put together to house his successful construction company for over 10 years. Don Hansen, world-class surfer, bought the property after returning from Hawaii in the early 1960s. The original building still sits along San Elijo Lagoon and houses the Kraken Bar and Grill. (Courtesy of Don Hansen.)

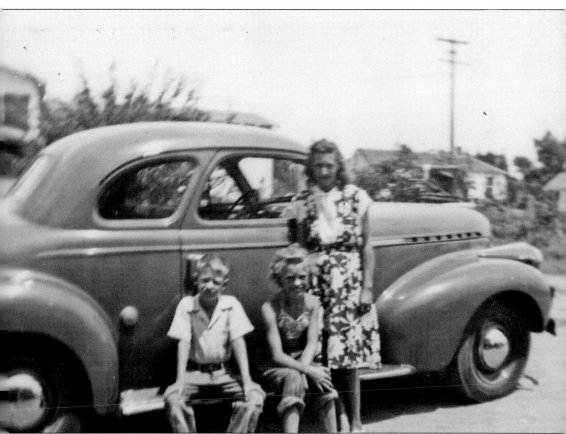

The White family relaxes in front of their home on San Elijo Avenue overlooking the ocean. Notable in this late-1940s photograph is the single electric pole in the background that served all of the neighboring homes. (Courtesy of Doug White.)

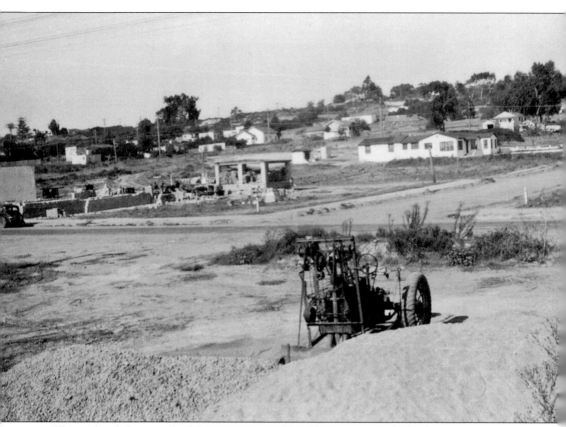

This undated photograph of the intersection of San Elijo Avenue and Aberdeen Drive is remarkable for what is missing. The foundation for the shopping center that houses VG Donuts is just being built, while only a few single-family homes exist on the hill sloping eastward. (Courtesy of Shirley Schroeder.)

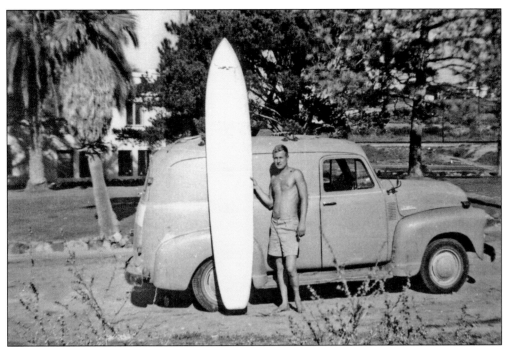

This late-1950s photograph shows a young Don Hansen beside his 1949 Panel Chevrolet—an ultimate longboard hauler for the surfer turned businessman. Hansen began his California surfing-industry odyssey in Cardiff in the mid-1960s with a small shop dedicated to shaping surfboards. His business has expanded into an all-board shop in Encinitas that serves customers worldwide. (Courtesy of Don Hansen.)

This late-1980s photograph depicts a teenage Rob Machado at the orthodontist's office celebrating getting his braces off. The Australian native's family moved to Cardiff when he was three years old. Despite a slight accent, Machado blended seamlessly into his new surroundings that he continues to call home. (Courtesy of the Machado family.)

In 1959, at the age of 15, Linda Benson became the youngest contestant to ever win the International Championship at Makaha. That same year, she was the first woman to ride Waimea, borrowing a board from the shortest guy surfing with her. The goofy-footed surfer continued to lead the charge as she won over 20 first-place surfing titles from 1959 to 1969. Her dedication to bringing other women of all ages into the sisterhood of surfing culminated in operating a surf school for five years. (Courtesy of Linda Benson.)

Rob Machado proudly displays a gift from one of his sponsors after winning the U.S. Nationals at 11 years old in this mid-1980s photograph. According to his mother, Chris, he rarely took off the then stylish and now very dated jacket. The young standout surfer became a world-class waterman, winning numerous contests as an amateur before going pro in 1993. (Courtesy of the Machado family.)

World-class surfer Rob Machado served as best man at his older brother Justin's wedding in 1996. Both siblings graduated from San Dieguito Academy High School in Cardiff, where they were standouts in both sports and academics. (Courtesy of the Machado family.)

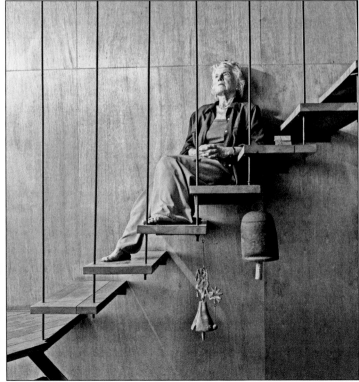

With nearly a century of experience to draw from, Dorthea Smith celebrated her first 90 years in 2008. The well-known and respected mother, businesswoman, artist, and designer has been a catalyst for change as well as preservation in the community. (Courtesy of the Smith family.)

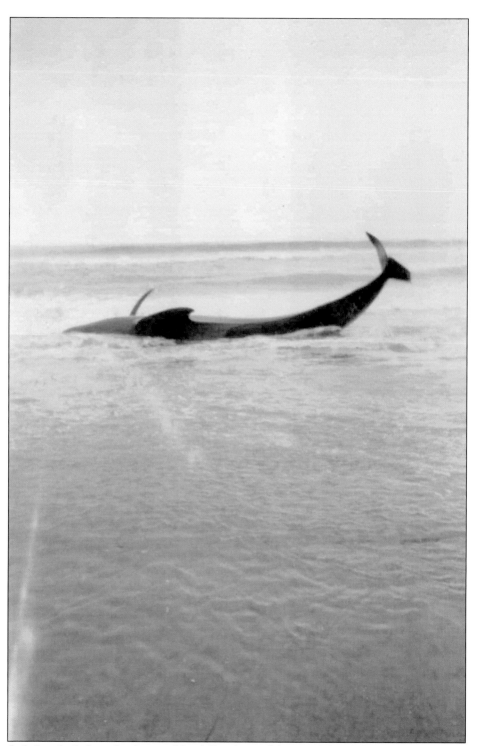

A whale beached along the shores of Cardiff in front of the Smith family home, where the Beach House Restaurant now stands. The 1940s photograph shows a rarity of nature along the coast where reefs still teem with wildlife. (Courtesy of the Smith family.)

Five

CHANGING TIDES

The backdrop of Cardiff has remained the Pacific Ocean throughout the modern era. Yet with a view from the water, the landscape has forever changed. The final vestiges of a seaside ritual came to an untimely end in the early 1970s as fisherman Stan Lewis took his last catch home from the sea. He and his fishing partner, Dick Dolman, broke through the hammering surf at Cardiff and Seaside reefs with a small fishing vessel known as a dory.

Others joined the well-known fishermen at the edges of the thick kelp beds to extract the highly valued Pacific spiny lobster. In a ritual that began before sunrise each day and ended with the last glimmer of dusk, Lewis would use instinct and landmarks to navigate through the waters to find fish that ran plentiful along the reefs. With a lifetime of experience as a "doryman," Lewis used his skill to earn a living from the bounty of the Pacific Ocean.

However, the modern age was slowly unraveling the traditional way of life for fishermen like Lewis and Dolman. Electronic devices used on larger vessels helped to fetch bigger daily catches, which drove down prices. The small skiffs were unable to compete.

The Pacific became more of a playground for visitors and residents than a source of sustenance. The "dorymen" are only a distant memory now as new generations of Cardiffians recall only surfers paddling through the shore break. The brief lobster season and lack of fish along Cardiff's coast are testament to the bygone era of the proud fisherman who once dominated the waters.

Linda Benson is shown nose riding in this early-1960s photograph. Benson still rides the waves at Cardiff and has brought parity to surfing competitions by lending her name and expertise to the annual women's ASP Longboarding Championships at Cardiff Reef, with a purse that is beginning to reach that of men's competitions. (Courtesy of Linda Benson.)

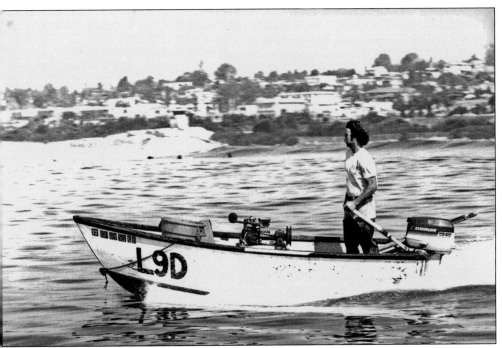

Tommy Lewis takes a ride in one of his fishing boats with the gently sloping hills of Cardiff visible in the background. This photograph, taken in 1970, shows the decreasing amount of untouched landscape giving way to residential and commercial development as the community grew in population. (Copyright © 1971 by Robert M. Wald.)

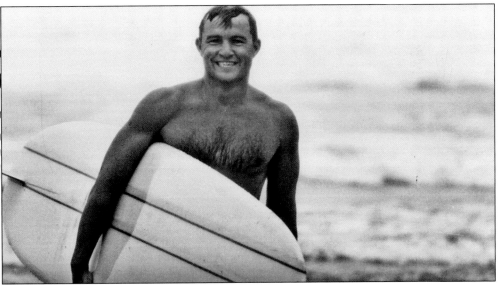

Don Hansen, a South Dakota native, came to Cardiff via Hawaii in 1962. The surfer began to develop a reputation as a premier board shaper when he opened his modest shop along the edge of San Elijo Lagoon that same year. This undated photograph shows Hansen carrying his signature single-fin longboard. Now in his 70s, Hansen says he does more horseback riding at his Montana home than surfing the crowded waves at the beaches of Cardiff. (Courtesy of Don Hansen.)

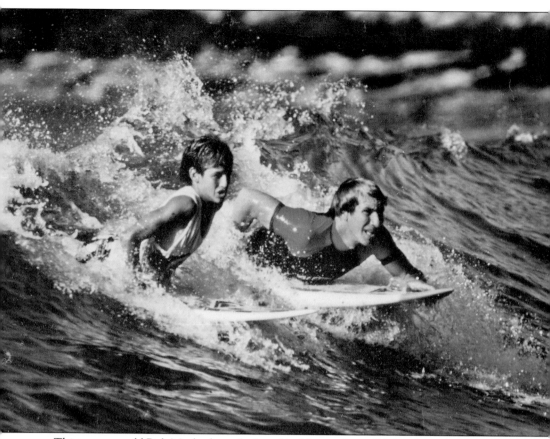

Thirteen-year-old Rob Machado surfs abroad in Venezuela in 1986 with his father, Jim. The two traveled together frequently as the elder Machado coached the U.S. Junior National Surfing Team for four years in the mid-1980s. (Courtesy of the Machado family.)

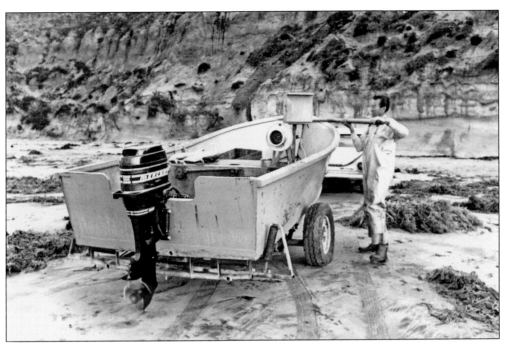

This 1971 photograph shows fisherman Stan Lewis preparing to depart for a day fishing the waters off of Seaside reef. (Copyright © 1971 by Robert M. Wald.)

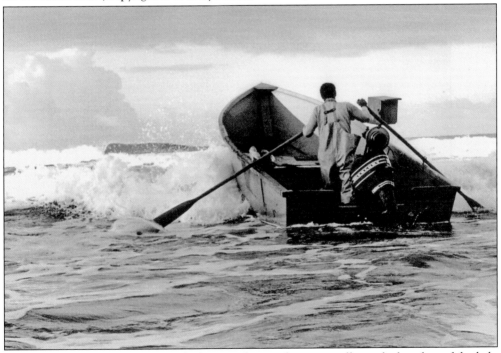

Stan Lewis paddles his skiff through the pounding surf to eventually reach the edges of the kelp forests. As seen in this 1971 photograph, fishing was often a solitary proposition. A day could last more than 14 hours depending on the size of the fisherman's catch. (Copyright © 1971 by Robert M. Wald.)

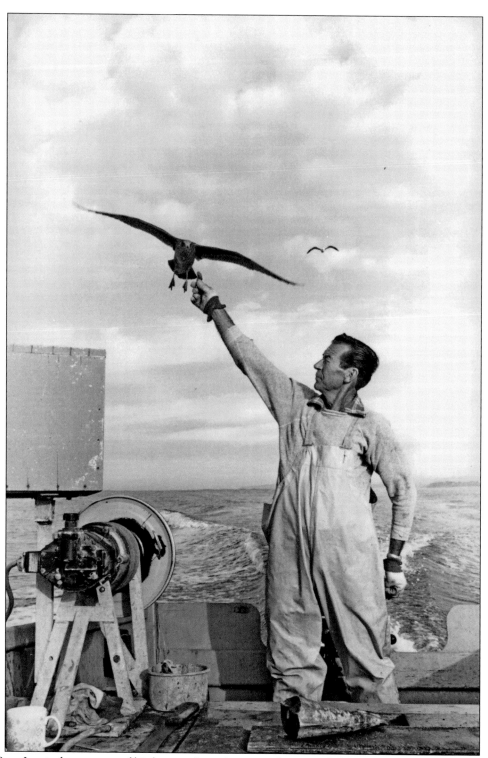

Stan Lewis shares some of his bounty from the sea with a seagull following nearby in this 1971 photograph taken off the coast of Cardiff. (Copyright © 1971 by Robert M. Wald.)

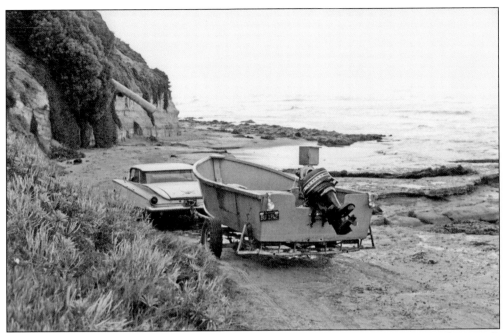

At low tide, Stan Lewis stages his boat for launching just south of Seaside. This 1971 photograph shows one of the drainage pipes in the background that mark the once towering cliffs that have slowly eroded. (Copyright © 1971 by Robert M. Wald.)

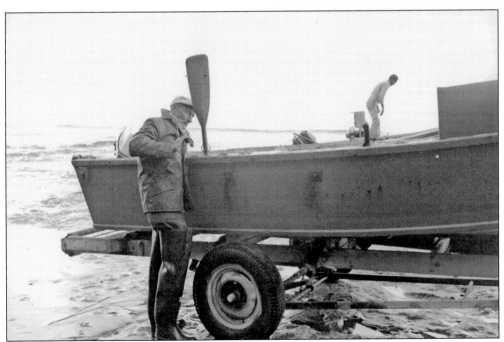

Dick Dolman checks the contents of his dory boat as he and Stan Lewis, shown in the background, prepare to launch their small fishing vessels at Cardiff reef in the winter of 1971. It was the last year the two were given access to depart from the area. (Copyright © 1971 by Robert M. Wald.)

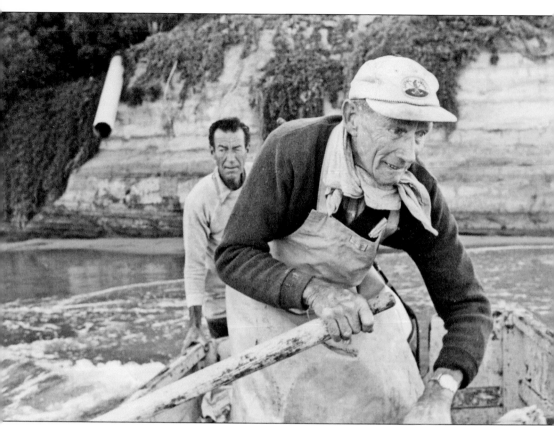

Dick Dolman is shown in the foreground navigating the dory into the impact zone of Seaside as Stan Lewis gently throttles the small boat's motor. The two fishermen were often seen together, as in this 1971 photograph, working as a team to extract the ocean's bounty of fish and lobster. (Copyright © 1971 by Robert M. Wald.)

Dick Dolman is the epitome of the solitary fisherman in this 1971 photograph as he embarks on a daylong expedition into familiar waters off the coast of Cardiff. (Copyright © 1971 by Robert M. Wald.)

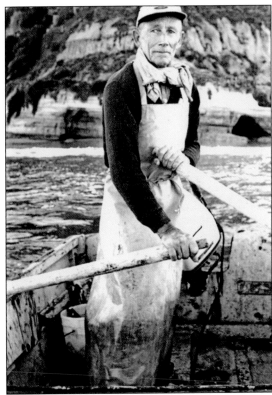

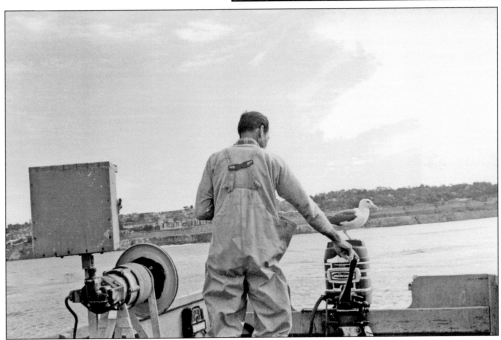

A seagull that was said to have accompanied him on many a fishing trip joins Stan Lewis. This photograph shows the southern border of Cardiff as it was in 1971. (Copyright © 1971 by Robert M. Wald.)

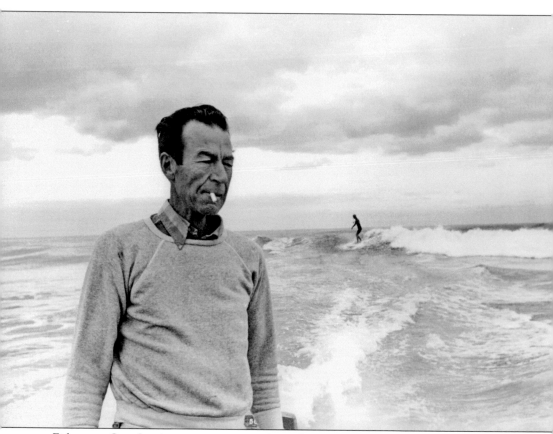

Fisherman Stan Lewis seems content to share the waves with a surfer as he navigates his boat toward plentiful fishing grounds in 1971. (Copyright © 1971 by Robert M. Wald.)

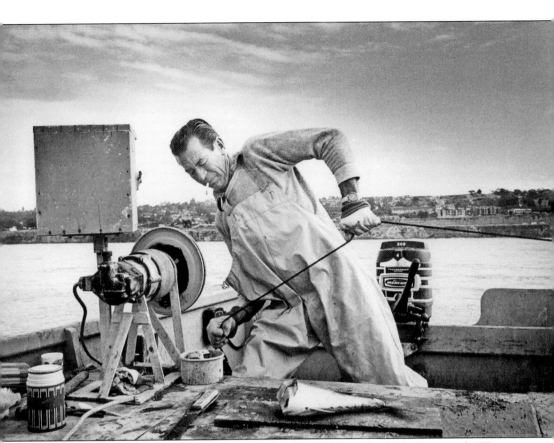

Stan Lewis brings in the line from a lobster trap with relative ease in this 1971 photograph. The Pacific spiny lobster caught off Seaside and Cardiff reefs brought in a handsome reward for the commercial fisherman. (Copyright © 1971 by Robert M. Wald.)

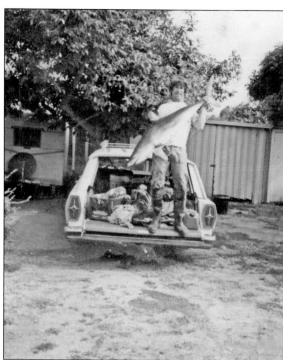

Commercial fisherman turned publisher Robert M. Wald proudly displays his catch of the day—a mako shark—in this early-1980s image. Wald now publishes *Ocean Magazine*, which emphasizes the water-based culture of the coastal region. (Copyright © 1971 by Robert M. Wald.)

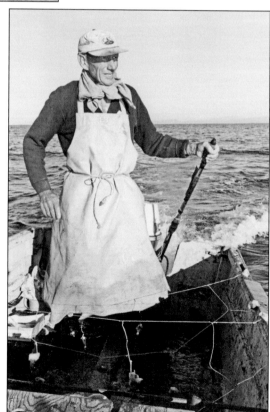

Dick Dolman motors his way into calm waters in this 1971 photograph. The commercial fisherman eked out a living from daily forays into the Pacific Ocean. (Copyright © 1971 by Robert M. Wald.)

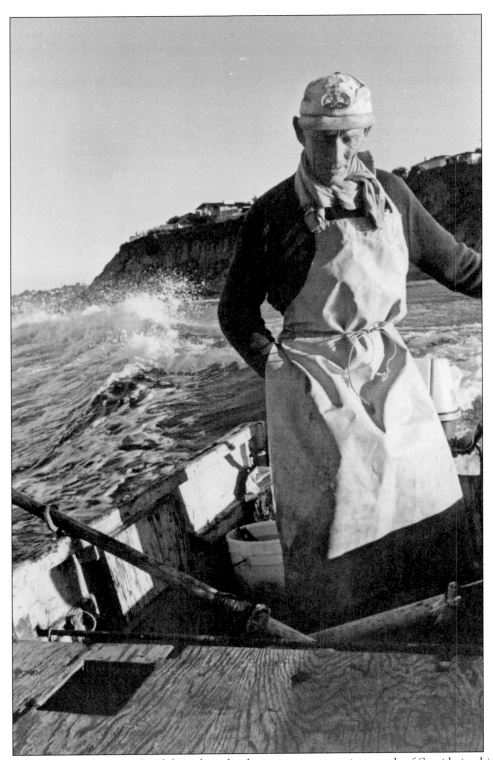

Dick Dolman is shown in his fishing boat lumbering over a wave just south of Seaside in this 1971 photograph. (Copyright © 1971 by Robert M. Wald.)

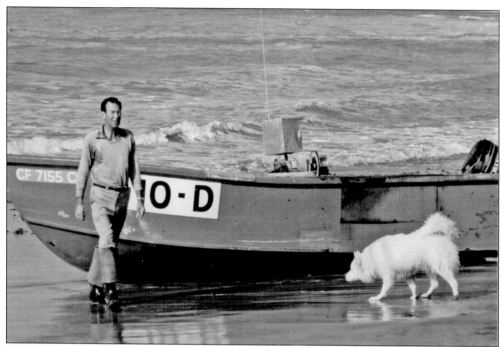

Stan Lewis takes a brief look around his boat on the beach at Cardiff reef as a dog sniffs for leftovers of the day's catch. The flat-bottom boat shown in this 1970 photograph was made specifically to glide over the waves at the shore. (Courtesy of Doug White.)

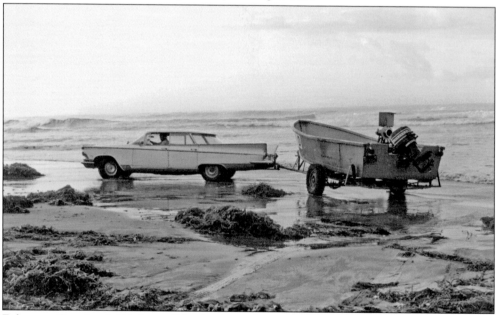

Fisherman Stan Lewis bids farewell for the day to the waters at Seaside. The clumps of kelp strewn along the beach in this 1971 photograph are evidence of a natural shedding process that occurs when the canopy of kelp thickens, cutting off vital sunlight to the layers below. As the algae begin to grow weak and thin, winter storms and changes in wind patterns tear them from the reef. (Copyright © 1971 by Robert M. Wald.)

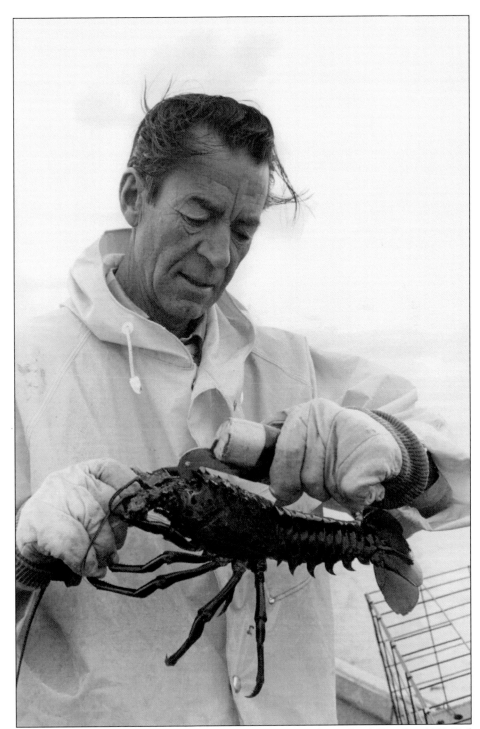

Stan Lewis measures a highly prized Pacific spiny lobster caught at Cardiff reef in 1971. Federal guidelines regulating the size of a legal catch have changed over the past 35 years as the population of this crustacean has diminished. Currently a minimal catch size of 3¼-inch-long body measured from the eye socket to the edge of the carapace is required. (Copyright © 1971 by Robert M. Wald.)

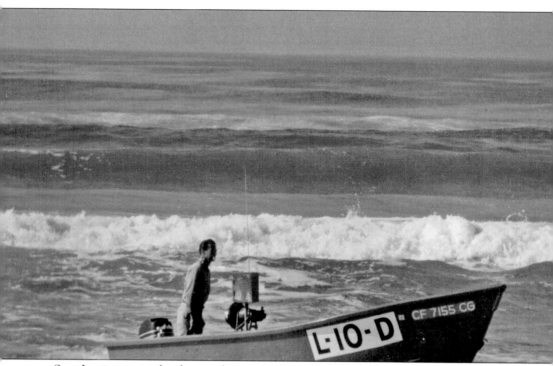

Stan Lewis surveys the shore as he prepares to pull out onto the beach at Seaside in this 1970 photograph. (Courtesy of Doug White.)

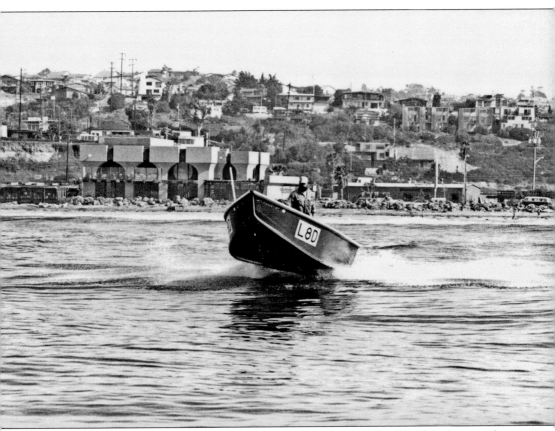

A commercial fisherman glides easily over the water as he heads out of Cardiff. This photograph taken in the mid-1980s shows the rapid expansion of commercial and residential development along the once barren hills of the small community. (Courtesy of Robert M. Wald.)

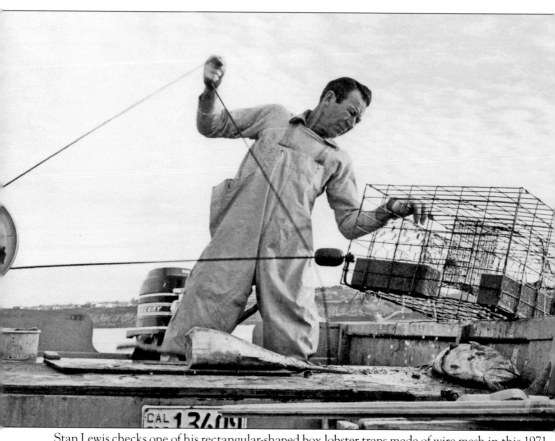

Stan Lewis checks one of his rectangular-shaped box lobster traps made of wire mesh in this 1971 photograph. The device was stuffed with cut fish to lure the highly lucrative Pacific spiny lobster off the coast of Cardiff. (Courtesy of Robert M. Wald.)

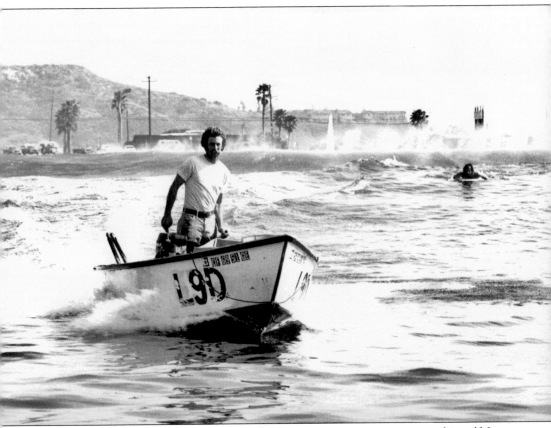

Tommy Lewis, whose father, Stan, was a renowned fisherman, grew up as a waterman himself. In this early-1980s photograph, Lewis travels quickly out to the open waters past a surfer paddling through the impact zone of Cardiff reef. The gently rolling hills east of San Elijo Lagoon are visible in the background. (Courtesy of Robert M. Wald.)

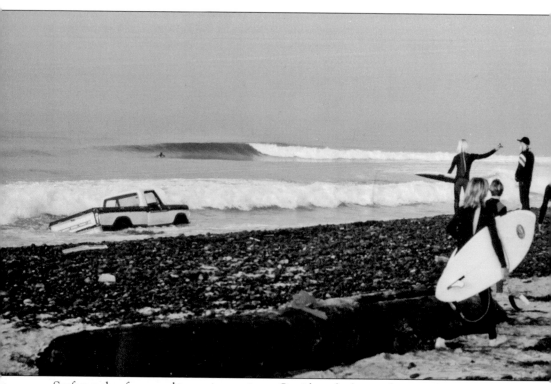

Surfers gather for an early morning session at Seaside to find more than just decent waves awaiting their arrival. The abandoned pickup truck in this mid-1980s photograph is in a precarious position as the incoming tide threatens to swallow it whole. (Courtesy of Doug White.)

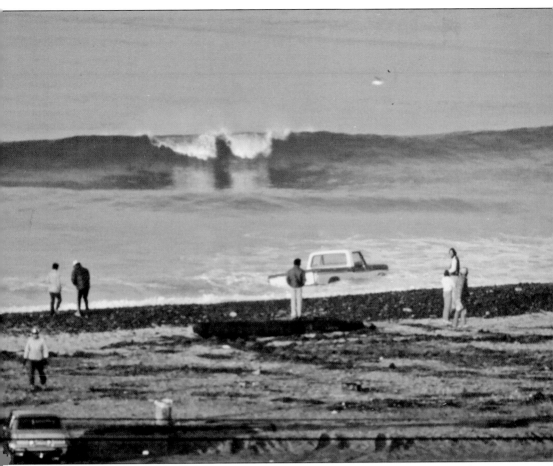

More onlookers gather as word of the abandoned vehicle's fate spreads in the early morning hours. Although Cardiff was still a tight-knit community in the mid-1980s, no one seemed to know who the owner was. (Courtesy of Doug White.)

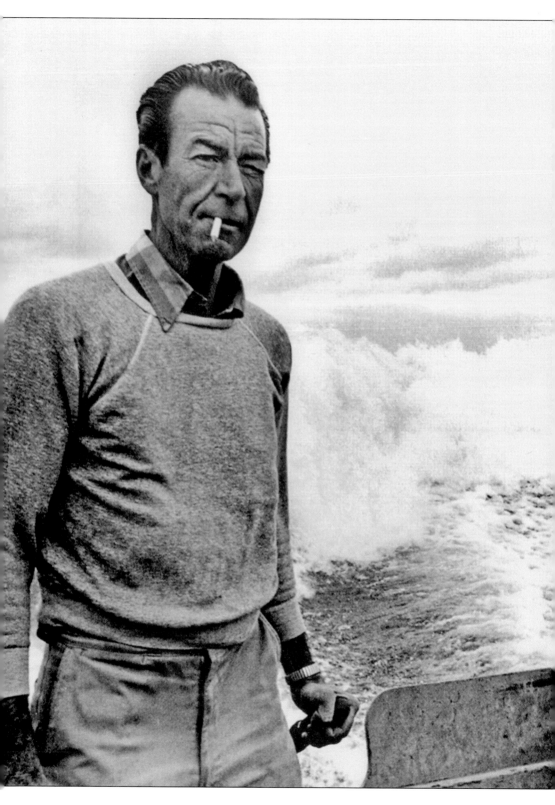

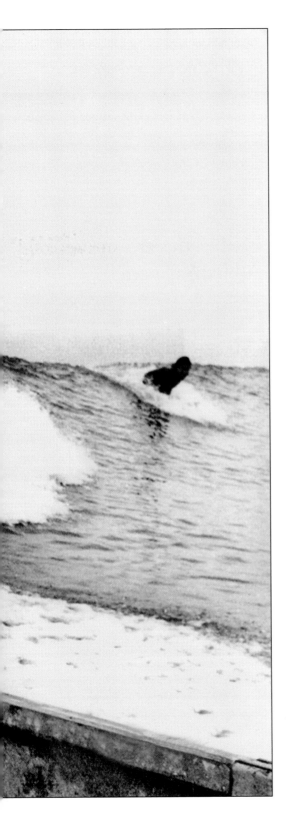

In his final days as a commercial fisherman, Stan Lewis shared the legacy of the ocean with others. Long gone were the days of solitude on the open waters, as this 1971 photograph depicts the changing tides of Cardiff. (Courtesy of Robert M. Wald.)

DISCOVER THOUSANDS OF LOCAL HISTORY BOOKS FEATURING MILLIONS OF VINTAGE IMAGES

Arcadia Publishing, the leading local history publisher in the United States, is committed to making history accessible and meaningful through publishing books that celebrate and preserve the heritage of America's people and places.

Find more books like this at
www.arcadiapublishing.com

Search for your hometown history, your old stomping grounds, and even your favorite sports team.

Consistent with our mission to preserve history on a local level, this book was printed in South Carolina on American-made paper and manufactured entirely in the United States. Products carrying the accredited Forest Stewardship Council (FSC) label are printed on 100 percent FSC-certified paper.

MADE IN THE